New American Art Museums

New American Art Museums

Helen Searing

Whitney Museum of American Art · New York
in association with the
University of California Press · Berkeley · Los Angeles · London

This exhibition is supported by a grant from IBM.

This book was published on the
occasion of the exhibition "New
American Art Museums" at the
Whitney Museum of American Art,
June 24–October 10, 1982.

Library of Congress Cataloging in Publication Data
Searing, Helen.
New American art museums.

Bibliography
1. Art museums—United States—Exhibitions.
2. Museum architecture—United States—
Exhibitions. 3. Architecture, Modern—20th
century—United States—Exhibitions. I. Whitney
Museum of American Art. II. Title.
NA6700.A1S4 1982 727'.7'097307401471 82-8412
ISBN 0-87427-038-3 (WMAA paper) AACR2
ISBN 0-520-04895-4 (UCP cloth)
ISBN 0-520-04896-2 (UCP paper)

Contents

Foreword

During the past five years an unprecedented number of American art museums have expanded, constructing new buildings or additions to older facilities. This building boom, which continues unabated, results both from a new awareness of the museum as a vital part of community life and from the changes that have taken place in museum programs in recent years. Several factors—more traveling exhibitions of popular subjects, higher attendance, active public education programs, the need for income-producing facilities such as sales shops and restaurants, the consequent demand for more staff— have forced museums to look for additional space.

The different styles and approaches visible in the designs for the museums in this exhibition reflect the diversity of American architecture today. Museums no longer universally follow the manner of classical temples. Patrons now seek unique buildings to encourage civic pride and attract attention. The particular projects in this exhibition and book were chosen to represent different types of museums (public, private, and university), as well as a broad range of collections and sites. Although the requirements of each of these seven institutions are unique, as a group they illustrate some of the problems inherent in museum architecture and offer a variety of solutions, addressing the issues of circulation, the use of natural or artificial light, and the design of spaces suitable for particular collections of art.

The generous support of IBM has enabled us to carry out the many extraordinary requirements of this endeavor. We are very gratified by their endorsement of the project and sincerely appreciate their help. This exhibition would not have been possible without the cooperation of both the architects and the staffs of the seven museums. We are grateful to Guest Curator Helen Searing, Professor of Art, Smith College, and Visiting Professor, Graduate School of Architecture and Planning, Columbia University, who organized the show and made the major contribution to this publication with her perceptive essay. We admire her knowledge and are indebted to her for skillfully orchestrating this complex endeavor.

Tom Armstrong
Director

American Art Museum Architecture

Since its emergence some 200 years ago as a specific building type, the art museum has occupied a compelling place in the history of architecture. In itself the embodiment as well as the repository of a given society's aesthetic values, the art museum focuses attention on architecture's dual nature as functional craft and expressive art. The architect's mandate here—the shaping of celebratory spaces revealed in light and experienced with heightened sensibilities—goes to the very heart of the architectural enterprise.

Art museum buildings reflect the changing course of architectural theory and design so pervasively that one could with some plausibility illustrate the history of modern architecture exclusively with examples of the genre. In some eras, museum architecture mirrors the major existing trends, but at other times, as in the earliest period of its existence and during the last quarter century, it is on the cutting edge.

In the art museum the tension between the typical and the particular that informs every architectural commission is vividly illuminated. The use of a uniform generic format is prompted by the building's highly specialized function of protecting and displaying works of art, and by the desirability of signaling as well as serving that function through the design. Nevertheless, the ultimately singular character of each museum tends to generate a more individualized image. As the art museum has become increasingly complex, evolving from a place solely for the contemplation of works of art into one encompassing educational, social, and even quasi-commercial activities, the conventional solution has given way to the heterodox at an ever-accelerating tempo. Technical innovations in structure, lighting, and environmental control have brought a new freedom from practical

constraints. Moreover, the fact that most new museums no longer arise in splendid isolation but are part of a larger architectural context impinges on design decisions in a way that accentuates formal distinctions.

Yet even in those periods when paradigmatic plans were developed and endured for a generation or more, resemblances between art museums were those of kin rather than clone. In the first place, there has never been a consensus about the key issues of circulation, illumination, and presentation. Some experts praise corridors which permit the visitor to bypass certain exhibitions and allow the temporary closing of individual galleries, while others prefer that passage through the museum take place primarily through the exhibition areas, which may be organized sequentially. Neither has there been accord about the best method of lighting the galleries. Before the advent of electricity, illumination meant for the most part natural light, but opinion has differed as to whether this should come from above through skylights, from the side through windows, or via clerestories which seem to combine the advantages of the other two systems. In the twentieth century, some degree of artificial illumination has become the rule, but whether it should be supplement or substitute remains an unresolved issue. As far as exhibition space is concerned, many curators demand an indeterminate, loft-like area, while others recognize the appeal of galleries with fixed dimensions. Some believe works of art should be shown in an intimate or casual setting, others that the character of the museum as a separate and lofty precinct be maintained. Some like to display art in period rooms, others abhor any background that is not wholly neutral.

Contributing to formal differentiation is the individual character of each museum's holdings. Programmatically, one might describe the museum as the public counterpart of the house, with the objects themselves as the tenants. Just as relatively unrepeatable configurations arise in residential buildings when the architect seeks to satisfy the differing needs of the clients, so must each museum building respond to the special requirements of its collections. And these have grown ever more heterogeneous. In the eighteenth century, paintings, statues, and precious *objets* were the only inhabitants of the galleries; today, machine-made products share occupancy with the mysterious and haunting artifacts of preliterate societies, and the performing and popular arts also command entry.

Arguably, then, the extraordinary diversity manifested in the art museum projects of the last five years, including the ones in this book, is unprecedented in degree rather than in essence. The diversity demonstrates the pluralism of contemporary architectural

practice no less than the current tendency for each institution to seek a unique identity that is legible as well as operational. At the same time the present inclination to reaffirm historical continuities in architecture and to reestablish the symbolic potential of three-dimensional form will encourage the visual expression of the museum's *generic* role as sanctuary of the arts. Thus, in many of the projects there are deliberate, if subtle, references to canonical examples of museum architecture.

These references are both reassuring and stimulating as we consider the art museum in history. The following pages offer such a consideration, although one that is brief and highly selective. The essay begins with some seminal European experiments, then focuses on American buildings, for it was in the United States that the art museum was adopted, adapted, and then transformed into the integral, indeed indispensable instrument of cultural and economic renewal that it is today. That art museums will continue to proliferate with heady optimism, catalysts for bold and provocative architectural design, the projects in this book attest.

The First Art Museums

The art museum as public institution and architectural type is a child of the Enlightenment, tangible testament to its belief in the power of reason and the capacity of man to perfect himself. Conditions for its emergence as an identifiable species—the revival of interest in the civilizations of the past, the enhanced status of the artist and his works, and the formation of private collections of art—had been gestating since the Renaissance, but the art museum as we know it today is a product of the second half of the eighteenth century.[1] At that time, democratic ideals of social equality, and the rise of the bourgeoisie with its cultural pretensions and ample leisure time, prompted demands that works of art be made accessible to everyone. The professional development of disciplines such as archaeology, art history, and art criticism during this period also contributed to the establishment of museums of art.

The first art museums expressly built as such were straightforwardly planned for the sequential viewing of works of art. Constructed at a time when classicism was dominant, they bore, as do so many of their descendants, the imprint of ancient Greece, imperial Rome, and Renaissance Italy. But the architects of the late eighteenth and early nineteenth centuries were hardly slavish imitators, and they used their sources with originality and logic. They often merged two tectonic

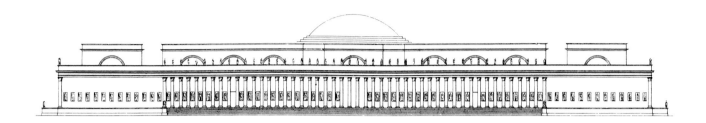

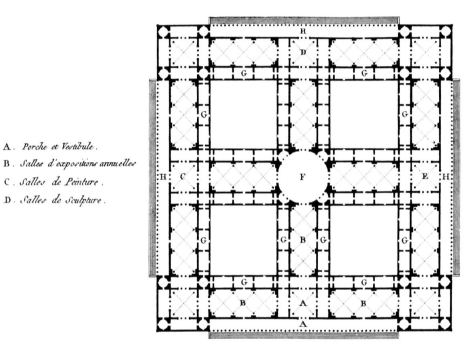

A . *Porche et Vestibule .*

B . *Salles d'expositions annuelles*

C . *Salles de Peinture .*

D . *Salles de Sculpture .*

E . *Salles d'Architecture .*

F . *Salle de Reunion*

G . *Cabinets des Artistes .*

H . *Entrées particulieres .*

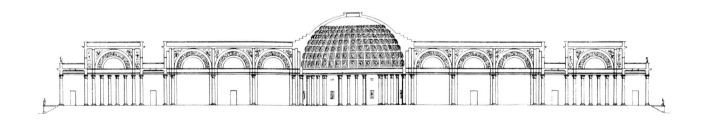

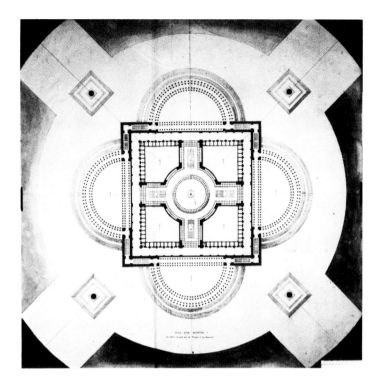

systems—the trabeated (post-and-lintel) system of the Greeks and the vaulted one favored by the Romans—in a single building to create a novel hybrid, just as they used familiar formats like the temple and the basilica for entirely new purposes. The use of a few basic formats was characteristic of the rationalism of the age, which permeated architecture as it did almost every area of human endeavor. Rationalistic also was the austere taste that eschewed unnecessary ornament, and the compositional emphasis on underlying geometric forms such as the cube and the sphere.

Such rational classicism can be seen in the work of the influential French teacher and author J.-N.-L. Durand (1760–1834), who published readily reproducible schemes for every conceivable building program, from traditional palaces and churches to the newer constituents of the modern city—libraries, prisons, markets, and museums.[2] His design for an art museum (Fig. 1) established a powerful precedent and demonstrates his rationalistic method of planning, where units of space and structure were suavely combined, horizontally and vertically, to compose the whole. Resembling to some extent ancient Roman bath buildings, his design was inspired by earlier French academic projects and by the sublime visions of his master, E.-L. Boullée (1728–1799), whose megalomaniac museum project (Fig. 2) dates from 1783. Durand has scaled this vision down and made it more feasible and efficient. The long colonnades which

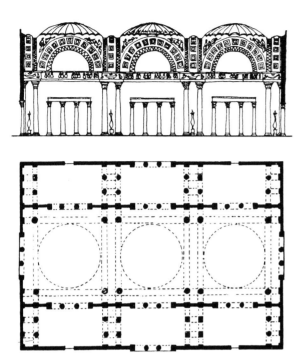

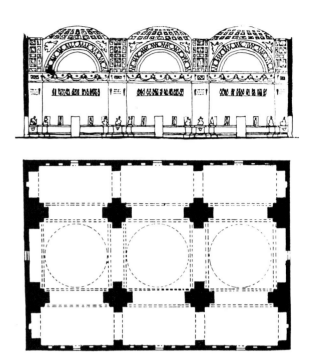

Fig. 3. J.-N.-L. Durand, Design for a Picture Gallery, 1805. Section and plan. (Durand, *Précis des leçons d'architecture*, Paris, 1802–5.)

Below:
Fig. 4. Glyptothek, Munich. Leo von Klenze, 1816–30. Section through Roman Galleries. (Von Klenze, *Sammlung architektonischer Entwürfe*, Munich, 1830–50.)

front the façades and the solid walls punctuated only by niches containing sculpture would become staples of museum architecture, as would the vaulted galleries lighted via arched clerestory windows. The galleries circumscribe four open courtyards and meet at the center to form a large rotunda supplied, like its model the Pantheon, with an oculus. Durand used a segment of this large scheme when suggesting alternative solutions for galleries (Fig. 3), solutions which would be insistently repeated during the first half of the nineteenth century.

The Glyptothek (Sculpture Gallery) in Munich of 1816–30 (Figs. 4–6) by Leo von Klenze (1784–1864) demonstrates the international

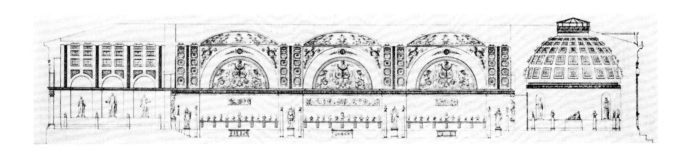

Right:
Fig. 5. Glyptothek.
Plan.

Below:
Fig. 6. Exterior.

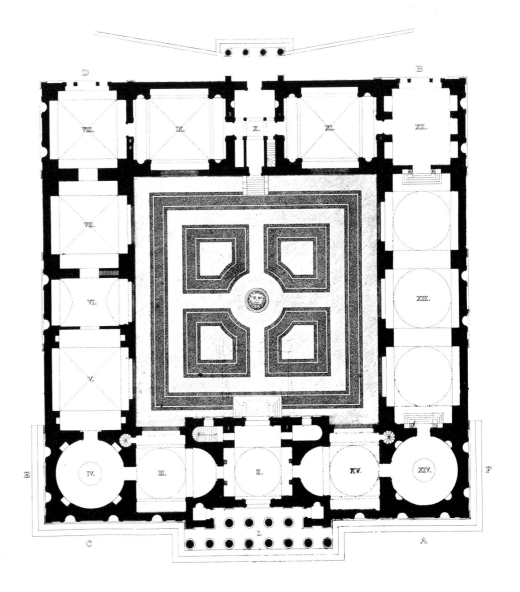

persuasiveness of Durand's paradigms, due no doubt to the scope they offered for individual interpretation and the flexibility that could be achieved by combining aspects of several schemes. Thus von Klenze has conflated with the picture gallery format (Fig. 3) a portion of the ideal museum plan (Fig. 1), eliminating corridors and arranging the rooms *en suite* around the single courtyard. The rotundas are top lighted; the galleries receive illumination from windows in the courtyard walls. The German architect has also mixed his sources, playing off the Greek temple front with its freestanding columns against the Renaissance niches which decorate the heavy exterior walls. Within there is an encyclopedic array of Roman vaulting forms. Just as the Glyptothek's contents—the collection of Ludwig I

Fig. 7. Altes Museum, Berlin. Karl Friedrich Schinkel, 1823–30. Plan of upper floor. (Schinkel, *Sammlung architektonischer Entwürfe*, Berlin, 1819–43.)

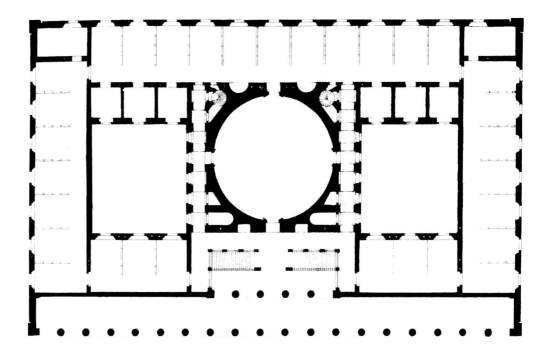

of Bavaria—offer a chronological overview of sculpture from Assyrian, Egyptian, Greek, Etruscan, and Roman times (one room—XV—was devoted to "modern masters"), so the building itself instructs through its historically generated structural and decorative forms.

Although it is a yet freer variant, the magnificent Altes Museum (Old Museum) in Berlin of 1823–30 (Figs. 7–10), by Karl Friedrich Schinkel (1781–1841), still echoes Durand's project of 1803. The Prussian work is two stories high, however, and introduces an imposing flight of steps which would convey the image "art museum" for a century or more. As in the Glyptothek, one proceeds circumferentially, through the ancient-sculpture galleries of the ground floor and the second-story rooms dedicated to painting. Beautifully proportioned Grecian windows on three sides of the exterior admit light; in the upper galleries, to compensate for the surface area lost to fenestration, Schinkel has set at right angles to the walls panels on which paintings may be hung. The climax of the composition is the Pantheon-like rotunda at the center that rises full height through the building.

With consummate skill and painstaking care, Schinkel has mated image and purpose down to the smallest detail. Creatively conscious of the museum's historical role, he designed picture frames to accord

Right:
Fig. 8. Altes Museum.
Section.

Below:
Fig. 9. Exterior from
Lustgarten.

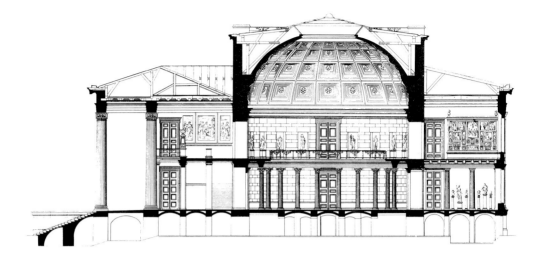

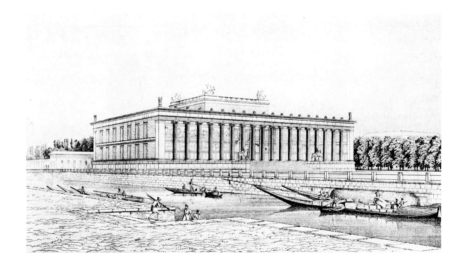

with the different stylistic periods of the paintings. The building itself is the architectural counterpart of the varied contents, collected by Friedrich Wilhelm III of Prussia, for Schinkel has employed his own versions of the three orders. Ionic columns march across the main façade, Tuscan Doric shafts punctuate the spaces of the sculpture galleries, and Corinthian columns appear in the rotunda. Simultaneously stimulating the senses and the intellect, the Altes Museum is a three-dimensional textbook of the classical language of architecture.

The soaring monumentality of Schinkel's masterpiece would become a standard feature of art museums throughout the nineteenth century in Europe and during the first three decades of the twentieth century in the United States. But the isolation such monumentality tends to produce is mitigated in Berlin by the open colonnade of the front

façade, which functions like an anteroom, creating a transitional zone between the space of the city and that of the museum. The Altes Museum in fact serves a dual function—actively participating in the surrounding environment while providing a sympathetic ambience for works of art.

A more intimately and idiosyncratically conceived building, housing not a royal collection but one formed by a philanthropic gentleman, is the Dulwich College Picture Gallery in London of 1811–14 (Fig. 11) by the brilliant Sir John Soane (1753–1837). Soane was a whimsical genius who treated the classical tradition with wit and irreverence, freely inventing his own orders and employing common materials like yellow stock brick and Portland "stone" (cement treated to look like marble) with a Picturesque abandon characteristic of early nineteenth-century English practice. The eccentricity of Soane's style was matched by the singularity of his commission—his picture gallery incorporated a mausoleum for the donor's family and six small apartments for the almswomen who had been previously lodged on the site; in its multifunctional conception, it thus program- matically foreshadowed today's museum.

As technically innovative as he was formally fanciful, Soane found imaginative solutions to the new architectural challenges of his age. It is not irrelevant to the present topic that he was architect to the Bank

Fig. 11.
Dulwich Col-
lege Picture
Gallery,
London. Sir
John Soane,
1811–14. Inte-
rior, Picture
Galleries.

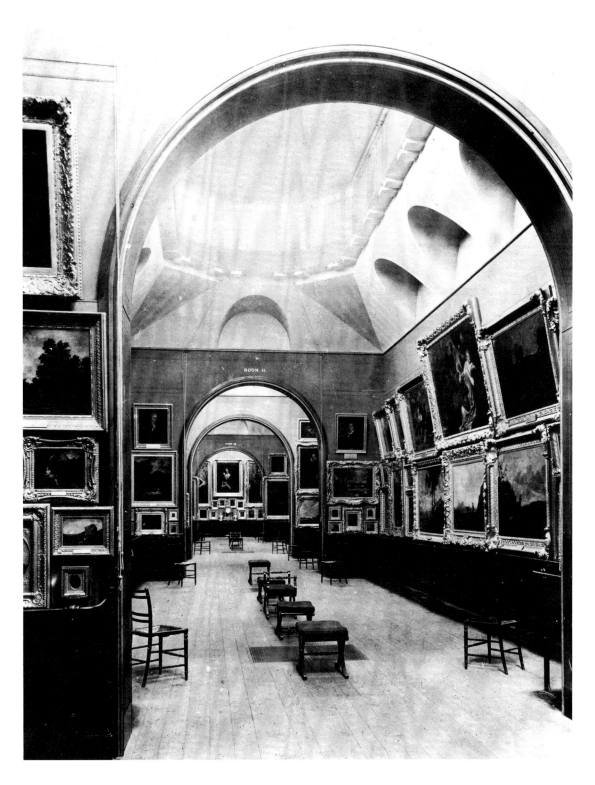

of England, where he also faced the problem of providing security. There, as at the Dulwich Gallery, his solution was the use of blank walls, which in turn necessitated top lighting. Soane experimented with several variations in the bank, and for the gallery devised a system of monitor lighting that has been widely praised. While working on the Dulwich Gallery, Soane commenced construction of his own private museum at Lincoln's Inn Fields, personally demonstrating the mania for collecting and display that brought the museum into being.

These three buildings in the classical vein, although only a small sampling of early art museums, are fully representative. During the second half of the nineteenth century, however, museums grew more disparate in style, under the impact of several successive historical revivals. They also became more diverse in their contents, as applied arts were added to collections of painting and sculpture. But fundamentally museums remained "temples of art," their stance vis-à-vis the community an elevated and passive one. It would be in the United States that the art museum, although initially slow to develop, would evolve into the lively and complex institution that it is today, a metamorphosis which would have important consequences for museum architecture.

The Art Museum in Nineteenth-Century America

It is very likely that the first completely detached new structure to be erected as a public art museum was the building constructed in Philadelphia in 1805–6 for the Pennsylvania Academy of the Fine Arts (Fig. 12).[3] Its collection, originally consisting of plaster casts after the antique, was opened to the public in March 1806 for an admission fee of 25 cents. In May 1811, at the instigation of the Society of Artists of the United States, the Academy initiated an Annual Exhibition, featuring contemporary work by Americans supplemented by European masterpieces borrowed from private collections; more than 500 paintings and sculptures were on display at this first event, which heralded the later practice of alternating temporary with more permanent installations.

The building, destroyed by fire in 1845 and known only from prints and drawings, was once thought to have been designed by Benjamin Latrobe (1764–1820), whose arrival on these shores in 1795 brought America its first professional architect. The author was in fact an amateur of far less renown, one John Dorsey, but the simplicity and crispness of the detailing and the geometric clarity of the massing

Fig. 12. Pennsylvania Academy of the Fine Arts, Philadelphia, First Building. John Dorsey, 1805–6; destroyed by fire, 1845. Exterior. Engraving by Benjamin Tanner.

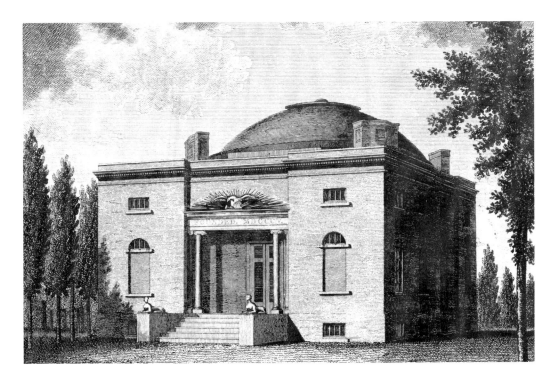

explain the attribution to Latrobe, as does the sophisticated conception of a top-lighted, domed rotunda at the center of the building. However, Latrobe embraced the monumental Romantic Classical manner, while the Pennsylvania Academy's first building belonged to the more *retardataire* Federal mode in its materials (brick with stone trim), and in the graceful, domestic character of its scale and composition; thus, the four shallow pavilions which define the corners have their origin in the eighteenth-century Anglo-Palladian house. Entirely in keeping with nineteenth-century ideas of expressive ornament, on the other hand, is the assertive iconography of the American eagle crowning the entrance, which brandishes in one talon the sculptor's mallet and in the other, the painter's palette and brushes.

Despite this precocious start, it would be almost three decades before another proper art museum was built in the United States.[4] This was the Trumbull Gallery in New Haven (Fig. 13), constructed by Yale College in 1831–32, at a cost of 5,000 dollars, to house the paintings of Colonel John Trumbull (1756–1843), who designed the building.[5] Trumbull donated his history paintings, portraits, and miniatures to Yale in exchange for an annuity and a suitable place to display them. They were hung on the upper floor of his building, in two rooms 30 feet square and 15 feet high, illuminated from above by skylights, which became the preferred American solution for many years.[6] Like

Fig. 13. Trumbull
Gallery, New Haven,
Connecticut.
John Trumbull,
1831–32; demol-
ished, 1901.
Exterior.

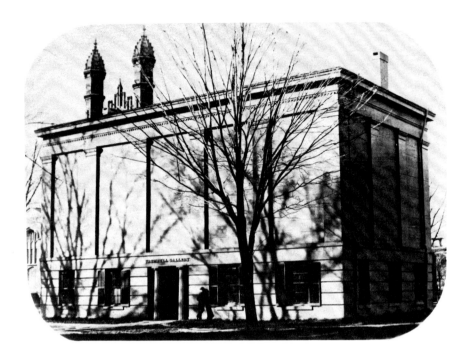

the Dulwich Gallery in London (Fig. 11), the first American univer-
sity art museum also functioned as a mausoleum; at Trumbull's
request, his body and that of his wife were buried in a crypt beneath
the building.

The Trumbull Gallery, with its simulated masonry surfaces and
baseless Doric columns and pilasters, was in the noble and primi-
tively severe Greek Revival style of the 1820s and early 1830s. It was
also touchingly provincial, for Trumbull, hailed for his scenes of the
American Revolution, was a far better painter than architect. The
proportions of his building were awkward, the entrance mean, and
the unfenestrated *piano nobile* (main floor) visually menacing. The
aesthetic shortcomings of Trumbull's design are manifest when it is
compared to an unexecuted project of approximately the same date
(Fig. 14) by his friend, Alexander Jackson Davis (1803–1892). This
previously unpublished drawing may be the first art museum pro-
posal in the United States to have been made by a professional
architect.[7]

The building is elevated both literally and figuratively, for by means
of the flight of steps and the axial planning Davis has created a
processional element that would have dignified the museum experi-
ence. While the barrel-vaulted room at the rear was fitted with
windows, the main gallery for painting, predictably, would have

Fig. 14. Alexander Jackson Davis, Project for an Art Gallery, c. 1831. Elevation, plan, and sections.

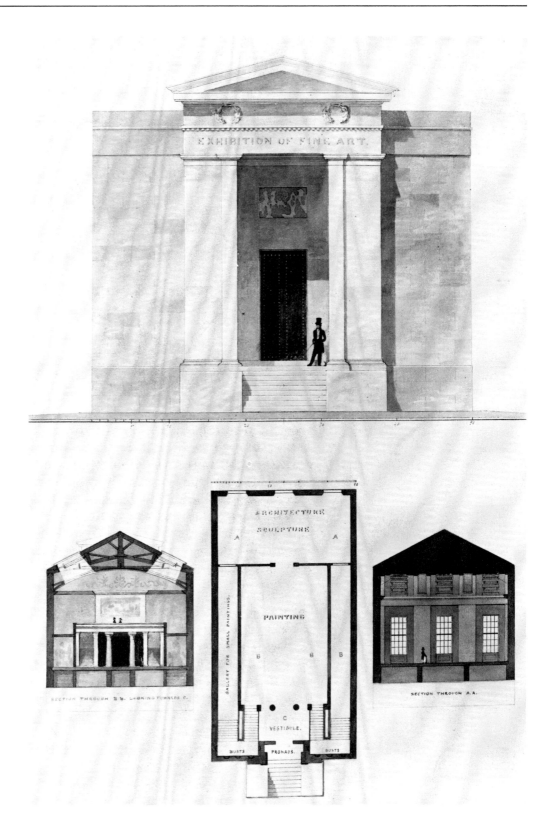

Fig. 15. Wadsworth
Atheneum, Hart-
ford, Connecticut.
Ithiel Town and
Alexander Jackson
Davis, 1842–44.
Exterior.

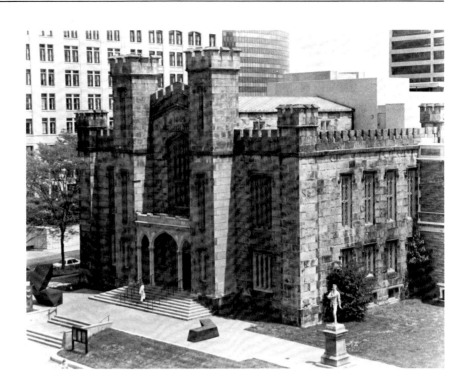

been top lighted. To mitigate the glare and direct the light toward the walls rather than the floor, Davis proposed setting the glass in the sides of the gable roof rather than at the crown. Significantly, Davis did not base his project on any European model but adapted to the museum program the strict temple format favored in the United States during this period for almost every building type. Not only does the outline of the building resemble a temple, but the organization of the plan follows that of the Parthenon, with a pronaos, naos (the central chamber for paintings), and cross-axial rear chamber, designed for the display of architecture and sculpture.

In the later 1830s, the castle replaced the temple as the ideal architectural icon. This shift toward more Picturesque and colorful modes is apparent in the Wadsworth Atheneum in Hartford, Connecticut (Fig. 15), which can be considered America's third art museum, although it housed a historical society and a young men's institute in addition to its picture gallery. The turreted and crenellated Gothic keep, of tan South Glastonbury granite, its traceried windows articulated by Tudor hood moldings, was constructed from 1842 to 1844 to the designs of A.J. Davis and his partner, Ithiel Town (1784–1844). While the firm of Town and Davis was famed for the chaste purity of its Grecian manner, the partners increasingly offered to their clients medieval alternatives, and in the Atheneum pointed museum architecture toward a new stylistic freedom.

Fig. 16. The Corcoran
Gallery of Art,
Washington, D.C.
First Building (to-
day, Renwick Gal-
lery). James
Renwick, Jr., 1859–
74. Exterior.

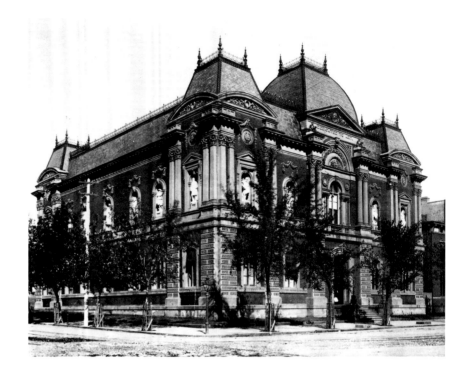

The dissolution of the authority of classicism unleashed an un-
paralleled eclecticism of taste.[8] Many different historical vocabul-
aries were simultaneously revived, but by the end of the Civil War
two imported styles had emerged as clear favorites—Ruskinian
Gothic from Victorian England, based on the secular architecture of
fourteenth- and fifteenth-century Italy, and Second Empire from
Napoleon III's Paris, a blend of French Renaissance and Baroque
motifs. Both provided lively polychromy, assertive massing, and
lavish ornament to a public whose growing thirst for conspicuous
opulence had been left unslaked by Neo-Classicism, and both would
leave a mark on museums in the United States.

The next public art museum to be launched, the first Corcoran
(today the Renwick) Gallery in Washington, D.C. (Figs. 16, 17), was
a precocious example of Second Empire. It was begun in 1859 but
not completed and occupied as a gallery until 1874. The architect
was James Renwick, Jr. (1818–1895), who personified eclecticism of
taste, engaging in the Romantic practice of selecting a style on the
basis of its associations. His first museum, the Smithsonian Institu-
tion, also in the capital, of 1846–55, was Neo-Romanesque; in St.
Patrick's Cathedral in New York City, of 1857–79, he emulated the
French High Gothic. For the Corcoran, he and his partner, Robert
Auchmutz, chose to imitate the palatial architecture of Bourbon
France as reinterpreted in the mid-nineteenth century, thereby recall-

Fig. 17. The Corcoran
Gallery of Art, First
Building. Interior,
main gallery.

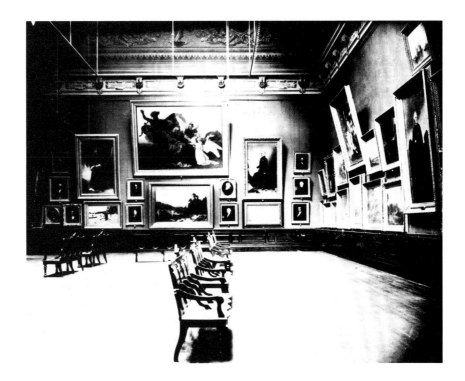

ing the fact that the first art collections were installed in royal residences. The Second Empire style brought into vogue the slate-covered mansard roofs, textured quoining (the arrangement of stones at the corners), aedicular pediments, segmental arches, and poly-chromatic materials (red brick and cream sandstone) that are such conspicuous features of the first Corcoran Gallery, erected for the sum of 300,000 dollars. It also allowed for decorative inventive-ness—thus the capitals of the columns and pilasters which adorn the second story are based not on the traditional acanthus plant but on Indian corn.

The rich ornamental program, which features statues of notable artists in the niches, clearly proclaims the building's purpose, as does the inscription, "Dedicated to Art." Such single-minded emphasis on aesthetics was still rare in the United States, where throughout the nineteenth century museums tended to be oriented toward practical ends. The Smithsonian is a case in point; its diverse contents included some works of art but it was far more richly endowed with objects of a scientific, historical, and technological character. In Renwick's second museum, the paintings, bronzes, and plaster casts of William Wilson Corcoran's collection were the sole tenants of the top-lighted galleries; an old photograph (Fig. 17) shows the standard nineteenth-

Fig. 18. Street Hall, Yale University, New Haven, Connecticut. Peter B. Wight, 1864–66. Exterior.

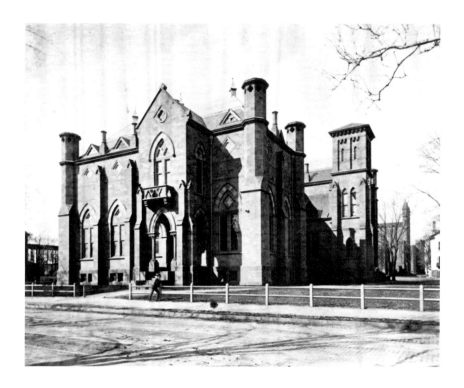

century method of hanging pictures on the high walls, ranged closely one above another.

The first examples of Ruskinian Gothic in America are represented not by art museums proper but by the more conglomerate *schools* of art, in particular two by Peter B. Wight (1838–1925): the National Academy of Design in New York City of 1863–65 (demolished), which evoked the Doge's Palace in Venice, and Street Hall at Yale University of 1864–66 (Fig. 18), a polytonal building of brownstone and sandstone.[9] When Yale became the first college in the nation to establish a School of Fine Arts, Wight was commissioned to design a building of studios and lecture rooms that would also accommodate the exhibition function previously served by the Trumbull Gallery. In the skylights and windowless walls of Street Hall's upper story, Wight continued the lighting practices established by Colonel Trumbull, but stylistically the old and new art buildings at Yale were worlds apart.

So were the successive structures belonging to the Pennsylvania Academy. Construction of the present building (Figs. 19–21), which cost 543,000 dollars, commenced in 1872. The design by Frank Furness (1839–1912) and his partner, George W. Hewitt

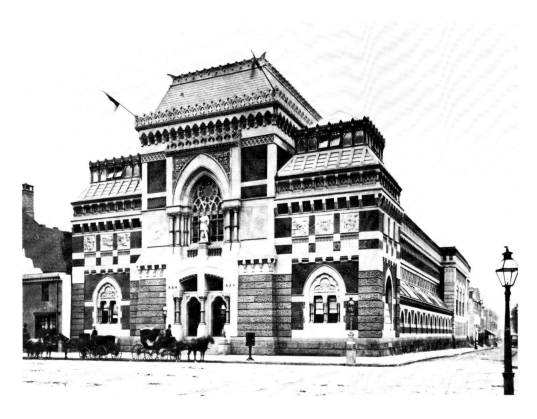

Left:
Fig. 19. Pennsylvania Academy of the Fine Arts, Philadelphia. Present Building. Furness and Hewitt, 1872–76. Exterior, c. 1880.

Below:
Fig. 20. Transverse section.

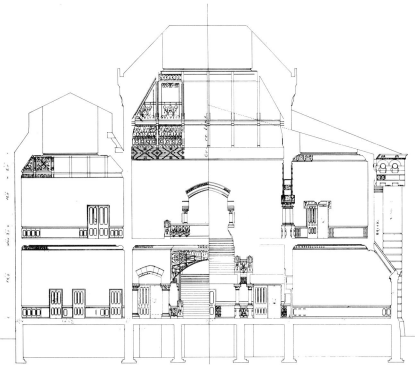

Opposite:
Fig. 21. Pennsylvania Academy of the Fine Arts. Stairhall and galleries.

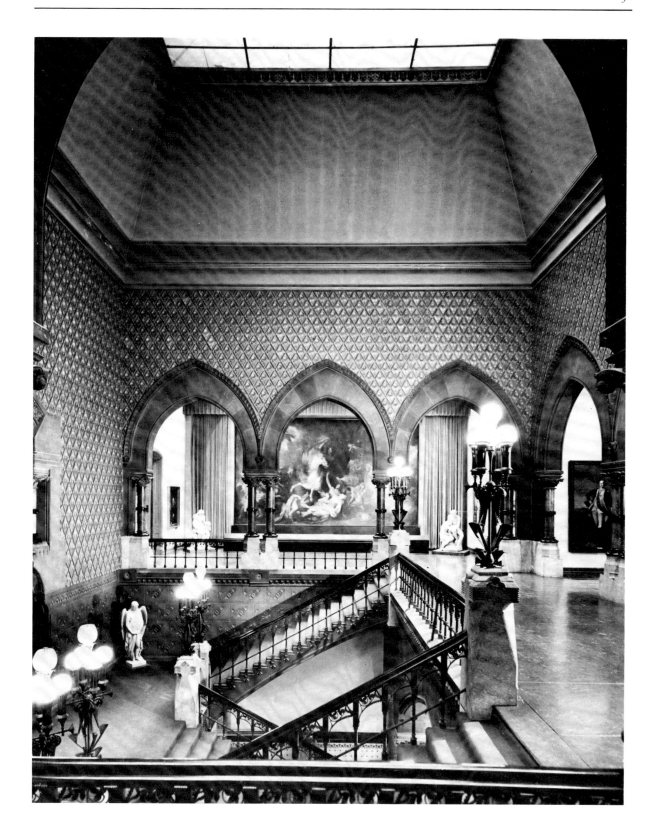

(1841–1916), dramatically documents that eclecticism of style which characterizes much of the architecture of the last third of the nineteenth century. Although the pointed arches, ringed columns, and permanent polychromy show Neo-Gothic inspiration, the segmental entrance arch, textured stonework, and overscaled, mechanistic ornament reveal the influence of the Second Empire and Neo-Grec Styles.[10] The palette of materials, astonishingly diverse and vivid, includes brownstone, granite, terra-cotta, sandstone, red and black brick, cast iron and bronze, and stenciled and pressed plaster. Like a later Philadelphia architect who would demand "both-and" rather than "either-or,"[11] Furness was an "inclusivist" who audaciously wove conflicting elements together to create an excitingly dissonant work that reflects the brash vitality of his age.

The lower story is devoted to studios, library, study areas and lecture hall while the upper floor is entirely given over to top-lighted galleries whose varied dimensions offer flexibility of display. The two sectors come together in the magnificent, meticulously detailed stairhall (Fig. 21). The building thus serves and symbolizes the mundane and sacred missions of the Academy—its teaching mandate and its long-standing commitment to public exhibitions. Here art is both made and contemplated. Railroad station and cathedral, the building's dualistic imagery suggests the nature of art as craft and religion. The Janus-faced architectural goals of the nineteenth century also fuse in this powerful work of historical reminiscence and bold transformation. In selecting Furness as its architect, the Academy reaffirmed the notion that the museum building itself should be a work of art.

Dedication ceremonies were held in 1876, the year in which two other major art museum buildings were completed: the first Museum of Fine Arts in Boston, a Ruskinian Gothic structure no longer extant,[12] and Memorial Hall in Philadelphia, built for the Centennial Exposition as a vast gallery of fine arts.[13] As the art museum pace began to quicken in the 1880s, Victorian Gothic and Second Empire buildings were joined by those in the bulky, round-arched Richardsonian Romanesque mode. Subsequently, in the final decade of the nineteenth century, it appeared that the stylistic wheel had come full circle, for classicism once again asserted its claims. One of the first examples of this return is the Walker Art Gallery at Bowdoin College in Brunswick, Maine, of 1891–93 (Figs. 22–24) by Charles Follen McKim (1847–1909), whose renowned firm of McKim, Mead and White would leave a vivid imprint on museum architecture in the United States.

In this, McKim's first executed design for an art gallery, he seems to have summed up almost a century of American museum architecture,

Right:
Fig. 22. Walker Art
Gallery, Bowdoin
College, Brunswick,
Maine. Charles Fol-
len McKim,
1891–93. Plan.

Below:
Fig. 23. Exterior.

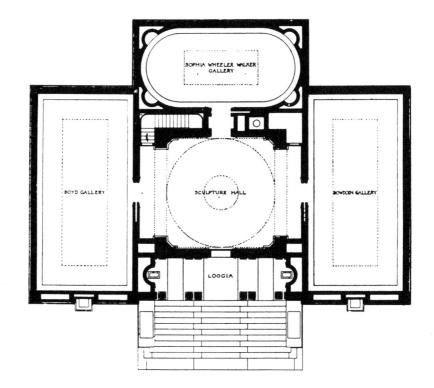

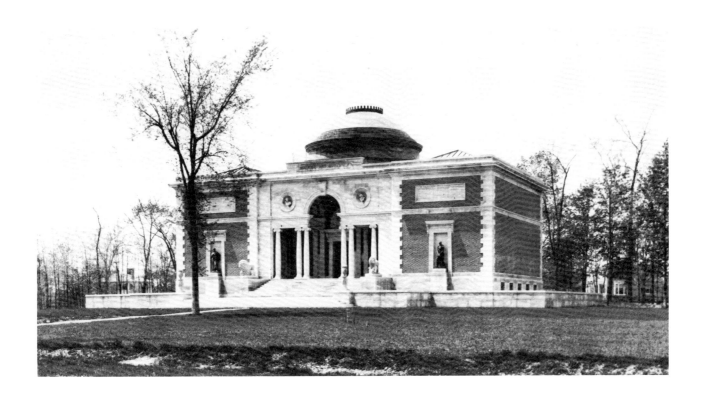

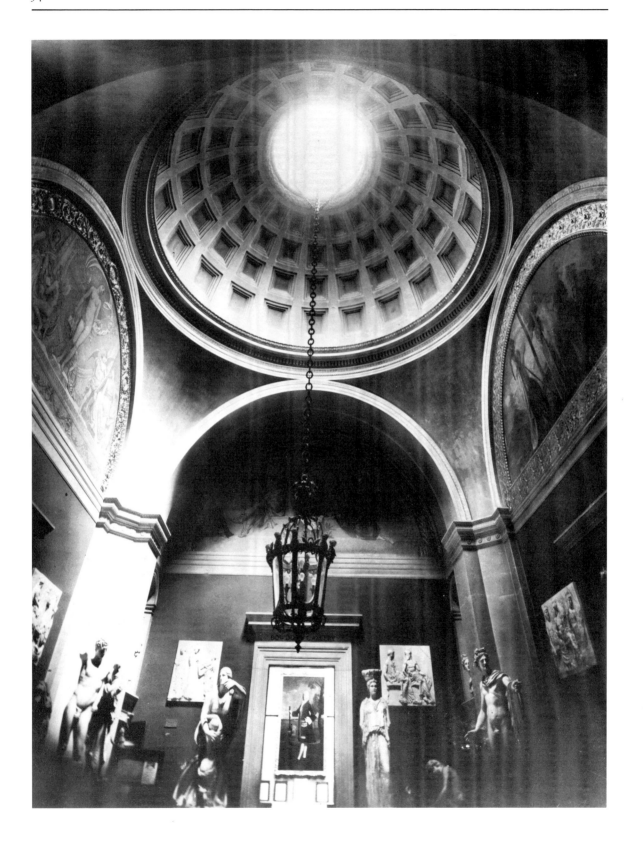

perfected in the direction of breadth and repose. He has restored harmony to the conventional tripartite composition (see Figs. 16, 19) by smoothing away projections in plan and silhouette and banishing the frenetic massing, the vertical emphasis, and the competition of the parts with the whole. Similarly, he has at once recalled and corrected America's first art gallery (Fig. 12). The centralized dome, the entrance loggia flanked by niches, and the brick walls evoke that vanished Federal structure. But McKim's Palladianism is fundamentally sixteenth-century Italianate rather than eighteenth-century Anglo-American, and it has led him to a serene monumentality.

For the decoration of the rotunda, McKim enlisted the talents of four American artists—John LaFarge, Elihu Vedder, Abbot Thayer, and Kenyon Cox—to paint allegorical murals representing Athens, Rome, Florence, and Venice, respectively. Such collaboration, especially fitting in an art museum, was one of the hallmarks of the movement often dubbed the American Renaissance. It developed in the late 1880s and replaced the stylistic rivalries of the earlier era with a broadly based academic classicism. Academic in its dependence both on precedent and on the design methods of the École des Beaux-Arts in Paris, where McKim and a growing number of Americans received training, this classicism found widespread popular acceptance at the World's Columbian Exposition, held in Chicago in 1893. When the first art museum building boom began in that year, to last until the Great Depression, public architecture had been inescapably cast in the classical mode.

Marble Halls: The Art Museum Building Explosion, 1893–1932

In 1912 an English visitor observed that "it is probable that more money and enthusiasm have been given during the last decade to the building of museums in America than in any other country."[14] His observation would remain true for another 20 years as Americans avidly amassed private art collections and donated them to public institutions with a generosity unmatched in history. It was not only the size and quantity of American art museums that attracted interest, however, but their eagerness to assume tasks beyond the traditional ones of acquisition, conservation, and display. The divergent demands of many constituencies were pressed and accommodated—the scholar and collector seeking knowledge, the artist and designer inspiration, the craftsman skill, and the layman aesthetic pleasure. The museum building became an ever more intricate organism that incorporated shops, lecture halls, restaurants, book and photo libraries, studios, accessible storage areas and laboratories, as well as the customary exhibition galleries.

Fig. 25. Typical mu-
seum plan. (Ben-
jamin Ives Gilman,
*Museum Ideals of
Purpose and
Method*, Cambridge,
Mass., 1923.)

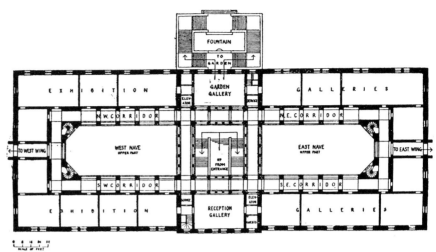

FIGURE 8. MAIN FLOOR

The archetypal image of the art museum familiar to generations of Americans was minted in this epoch. Large or small, compact or sprawling, totally new structure or addition to an existing one, the museums that arose from coast to coast during these four decades have a family resemblance, fostered by the employment of a classical vocabulary and a Beaux-Arts compositional method. They are unabashedly civic monuments, facing street, park or plaza with a self-assured integrity, and movement toward and through them is deliberate and ceremonial. Open or roofed courtyards to either side of the entrance axis are a common feature, as are exterior and interior staircases that impart a sense of ritual.

Heretofore museums in the United States followed no pattern and were recognizable chiefly by their blank walls and skylights. But from 1893 to 1932 it was a rare museum that did not have as its starting point the scheme reproduced in Fig. 25 which, although providing greater spatial differentiation, ultimately goes back to Durand (Fig. 1) and the Altes Museum (Fig. 7). There were many versions of this *parti* (overall composition), however, depending on the location and programmatic needs of the particular museum. Methods of lighting became more varied as increasingly sophisticated systems of artificial illumination were employed. While skylights continued in use, side and clerestory (or attic) windows were introduced to provide a different quality of natural light. There was further opportunity for individual interpretation through the choice of model: the Greek temple, Roman basilica, Renaissance palace, and Beaux-Arts *grand prix* (competition-winning design) were all deemed appropriate for imitation and metamorphosis, and in the 1920s American Georgian and Art Moderne were embraced as well.

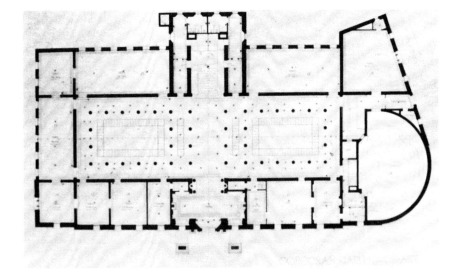

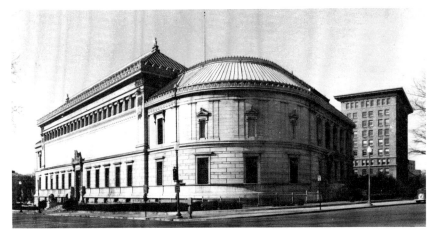

One of the first museums in the new manner is the second Corcoran
Gallery of 1893–95 (Figs. 26–28) by Ernest Flagg (1857–1947). A
graduate of the École des Beaux-Arts, Flagg won the competition
underwritten by the Corcoran in 1892 when it had outgrown its
previous headquarters. His plan incorporates an art school with
studios, a library, offices, and a spacious semicircular auditorium,
but at its heart is the top-lighted atrium, 150 feet in length, that
extends at right angles to the entry. The atrium, used to exhibit
sculpture, permits maximum freedom of access to the two stories of
encircling galleries.

This second Corcoran makes a telling contrast with its predecessor.
Renwick had visited Paris in the 1850s, while Flagg, who was *trained*
there in the 1880s, imported a more recent and restrained brand of

Fig. 28. The Corcoran
Gallery of Art.
Atrium.

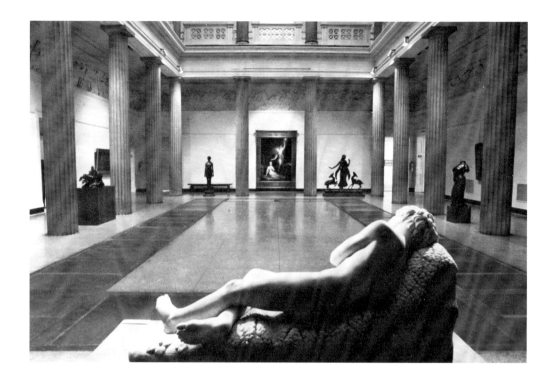

classicism. His building, its Georgia-marble walls rising resplendently above a granite base, its Grecian details extremely refined, its massing horizontal and stately, is in many ways a highly personal statement, but it established a standard for museum architecture that was immediately recognized by Flagg's contemporaries, who lauded his design for

> that massive dignity and grave imperiousness which so well
> become a building whose main object is at once to inspire by its
> very exterior reverence for beauty . . . and to preserve within . . .
> great objects of art.[15]

A purer Greek, without the French accent, is spoken by the Albright (today Albright-Knox) Art Gallery in Buffalo, of 1900–5 (Fig. 29) by Edward B. Green, Sr. (1855–1950), of the firm of Green and Wicks. The building, of white Maryland marble, was the first museum of the acropolis type in the United States. Set in a park overlooking a lake, it is an elegant Ionic collage with souvenirs of the Erechtheum overlaid by memories of the Glyptothek (Fig. 6) and the Altes Museum (Fig. 9). The Albright Art Gallery is another example of the collaborative spirit of the American Renaissance, for its caryatids, representing the arts, were designed by Augustus Saint-Gaudens. The organization departs from the more usual type seen in embryo at the Corcoran; the exhibition areas are all on one level and a lofty central entrance hall replaces the lateral courtyards as a sculpture gallery. However,

Fig. 29. Albright
(-Knox) Art Gallery,
Buffalo, New York.
Edward B. Green,
1900–5. Perspective,
plan, and elevations.

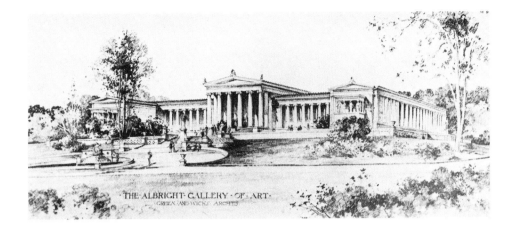

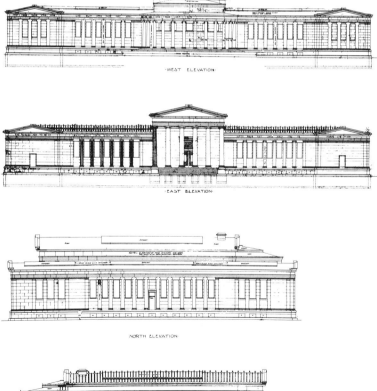

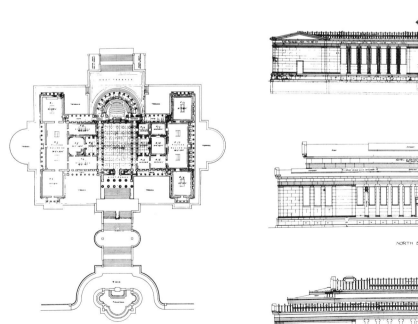

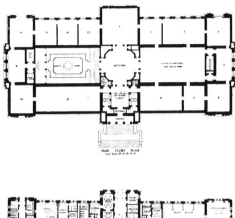

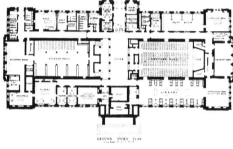

Fig. 30. The Cleveland
Museum of Art.
Hubbell and Benes,
1916. Plan.

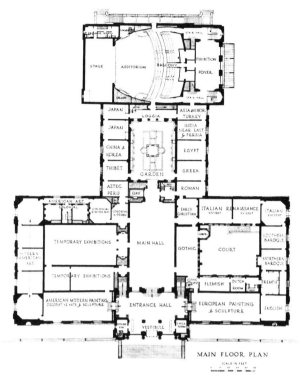

Fig. 31. The Detroit
Institute of Arts.
Paul P. Cret and
Zantzinger, Borie
and Medary, 1927.
Plan.

Fig. 32. National
Gallery of Art,
Washington, D.C.
John Russell Pope;
completed by Eggers
and Higgins, 1941.
Plan.

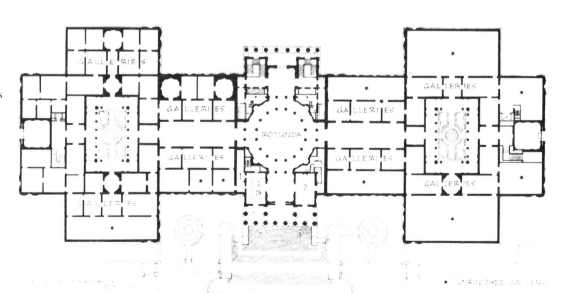

Fig. 33. Museum of Fine Arts, Boston. Guy Lowell, 1906–31. Plan.

the two plans would often be mated to produce a hybrid strain of great popularity, as at Cleveland (Fig. 30), Detroit (Fig. 31), Washington, D.C. (Fig. 32) and Boston (Fig. 33).

Like the Albright Art Gallery, Boston's second Museum of Fine Arts is also an Ionian acropolis, but one conceived on a far vaster scale (Fig. 34). It was erected in stages after extensive studies, which commenced in 1902, determined a set of design principles that are worth recapitulating as symptomatic of museum thinking of the time. These were 1) *division in plan* into structurally separate departments classified according to the civilization represented (e.g. Japanese, Classical, Western) and having independent circulation patterns—in effect, the building is not a single museum but a group; 2) *division in elevation* into a main exhibition floor for the public on the *second* story and a reserve and study section for the specialist on

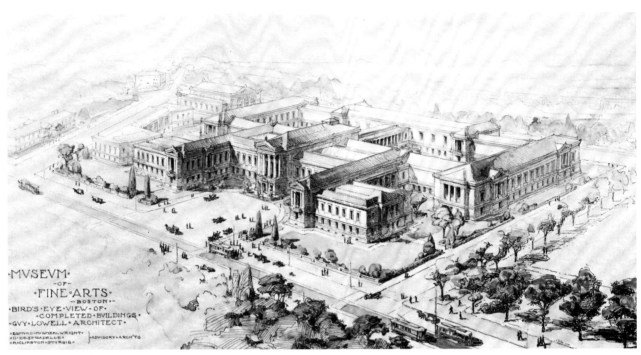

Fig. 34. Museum of Fine Arts, Boston. Design for the completed museum adopted July 1906; some portions not executed. Bird's-eye view.

the ground floor; this became the standard arrangement for large museums; 3) *ample natural light* in every room on both floors; this was chiefly oblique, for windows were introduced to an unprecedented degree, but the major galleries of the upper story were also fitted with skylights.[16] Despite the extraordinary preparations, practical problems did arise and the arrangement has been altered over time (see Fig. 58). Nevertheless, the original intentions can be read in the plan and still experienced in the museum.

Guy Lowell (1870–1927), trained at Harvard, M.I.T., and, during 1895–99, at the École des Beaux-Arts, worked out the design, based on the recommendations of an architects' committee. Of all American museum plans his most clearly reflects the compositional devices taught at the Parisian academy. He has followed the favored *parti* of *cour d'honneur* (forecourt flanked by extended wings), *corps de logis* (main building), and garden court(s); Lowell has closed these off by a large wing parallel to the *corps de logis*. The latter, constructed 1907–9, echoes the composition adumbrated in the Corcoran Gallery, but the ascent to the second story via a *grand escalier* is far more imposing. The Evans Memorial Wing, on the other hand, facing the Fenway and executed 1911–15, is not unlike the Albright Gallery in plan. The Decorative Arts Wing (J and K on the plan), was completed in 1931, thereby realizing one of the garden courts envisaged by Lowell, but the remaining portion of his Beaux-Arts *parti* was never consummated.

Fig. 35. Fogg Art Museum, Harvard University, Cambridge, Massachusetts. Shepley, Rutan, and Coolidge, 1927. Exterior.

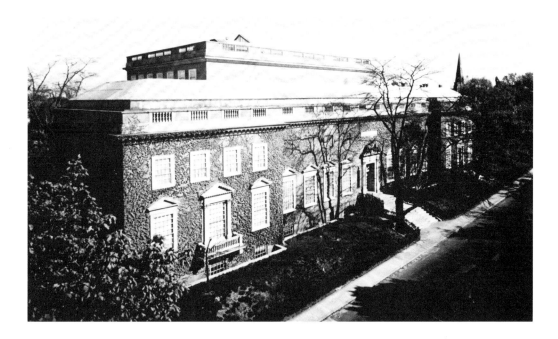

It should be noted that for their second museum, the Boston trustees not only moved the site from densely textured Copley Square to a 12-acre plot adjacent to the Fens in relatively undeveloped Back Bay, but also repudiated the Victorian Gothic style of the first building. As one of them wrote:

> The new building was not deliberately planned as an architectural monument but inevitably became one from the dignity of its purpose and the necessary amplitude of its extent. . . . A museum of fine art should convey the positive assurance that that which is to be seen within shall be of the best that men have imagined and wrought. For such a conception the architectural style at once suggested is the classical.[17]

The last sentence could describe most of the art museums erected during this century's first three decades. Classical, too, after all, is the Georgian Revival, which came into vogue in this period, especially for collegiate architecture. The choice of Georgian over Grecian, Roman or Beaux-Arts was usually determined on the basis of context, for the materials—red brick with white trim—and the more residential dimensions of this style were particularly sympathetic to the Colonial, Federal and Victorian structures found on so many American campuses. It is not surprising, therefore, that early examples of Georgian Revival adapted to the museum program are found in Providence, at the Rhode Island School of Design, of 1925, and in Massachusetts, at the Tryon Gallery of Smith College in Northampton, of 1926 (demolished), and the Fogg Art Museum at Harvard University, of 1927 (Figs. 35, 36).

Fig. 36. Fogg Art
Museum. Court.

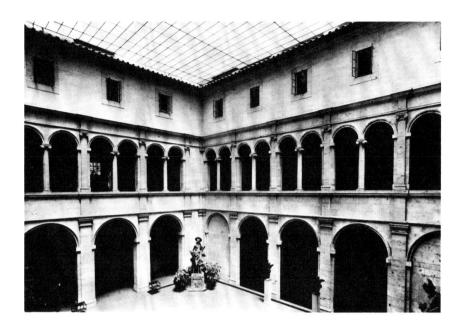

On the exterior, the Fogg Art Museum, by the venerable Boston firm of Shepley (George Foster, 1860–1903), Rutan (Charles Hercules, 1851–1914), and Coolidge (Charles Atherton, 1858–1936), is respectful of Harvard's existing buildings. Inside, as befits a teaching museum where architecture is cherished as one of the fine arts, gestures are made to the European heritage, through the incorporation of decorative fragments, and the reproduction, for the top-lighted court, of the façade of the Canon's Palace in Montepulciano by Antonio da Sangallo the Elder (1455–1534). An important innovation at the Fogg was the system of accessible open storage adjacent to the exhibition galleries on the second floor. The front galleries of the second story have skylights; elsewhere, light is admitted through the domestically scaled windows. The stairway, located off the courtyard, is also intimate rather than grandiose.

Probably the ultimate in classical permutations is the Art Moderne or Art Deco style, named because its debut was at the 1925 Exposition des Arts Décoratifs in Paris. This style, illustrating the infinite versatility of the classical vocabulary, answered the demand for a classicism that would also be contemporary. An exquisite example is the Gray Museum (today Museum of Fine Arts) in Springfield, Massachusetts, of 1931–33 (Figs. 37–39), by Edward L. Tilton (1861–1933) and Alfred Morton Githens. The modernist taste for smooth and simple surfaces is evident here; except for the frame

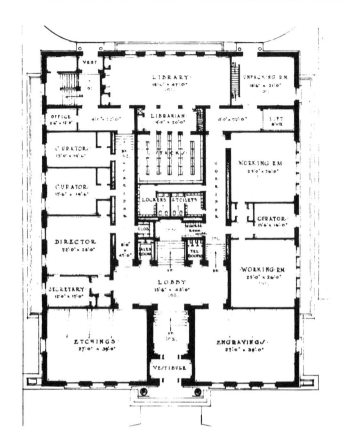

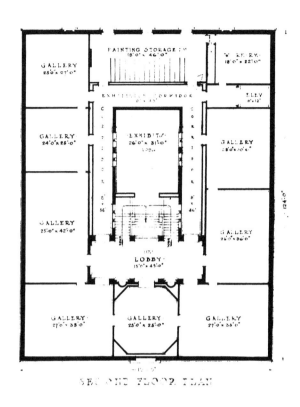

Above:
Fig. 37. Museum of Fine Arts, Springfield, Massachusetts. Edward L. Tilton and Alfred Morton Githens, 1931–33. Plan.

Right:
Fig. 38. Exterior.

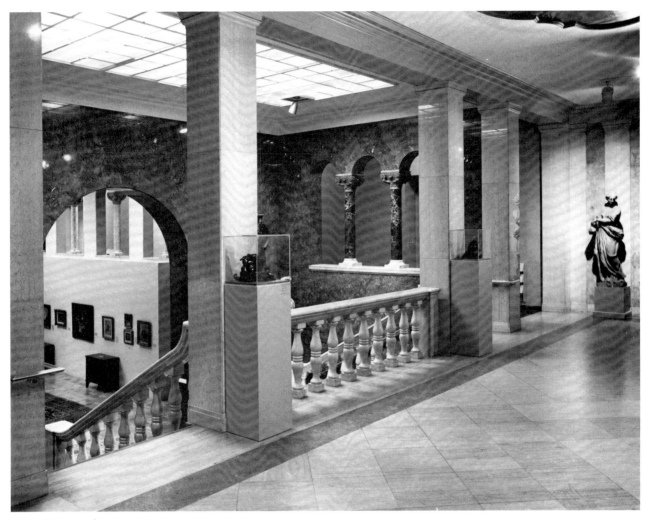

Fig. 39. Museum of Fine Arts, Springfield. Stairhall and galleries.

around the entrance, all of the details are carved back from the frontal plane and there are no applied columns or pilasters. The signs of the zodiac in hexagonal settings ornament the blank walls of the second story, which is crowned by a zigzag motif traced in gray marble against the limestone ashlar masonry.

The inherent flexibility of classicism is also demonstrated by the plan. The architects have produced a compact and elegant version of the standard museum *parti*, merging stairhall and court into a single, organizing core. The offices and rooms for graphic arts on the ground floor are lighted by windows, the galleries above are top lighted, and the generously proportioned exhibition corridor receives diffused light from the central stairhall/court. For a fascinating insight into both the static and dynamic aspects of classical architec-

Fig. 40. Clarence Stein, "The Museum of Tomorrow," 1929. Plan. (*The Architectural Record*, 67 [January 1930].)

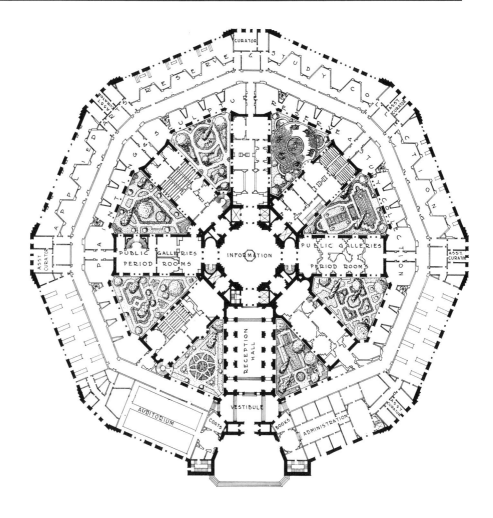

ture vis-à-vis the art museum, the Springfield Museum of Fine Arts should be compared with an antecedent precisely 100 years its senior—the Trumbull Gallery which once stood in New Haven (Fig. 13).

A curious and unrealized design from this era was that for a museum skyscraper (Figs. 40, 41). First proposed in 1927 by Lee Simonson,[18] it was given architectural form in 1929 by Clarence Stein (1882–1975), best known today for new town schemes like Radburn, New Jersey. Stein's "Museum of Tomorrow" was intended to address the enormous size of American collections and the consequent problems of differentiating between the public's "Museum of Inspiration" and the student's "Museum of Education,"[19] between the desire of the layman to view a few carefully selected objects and that of the scholar to see the entire holdings in a given category. The

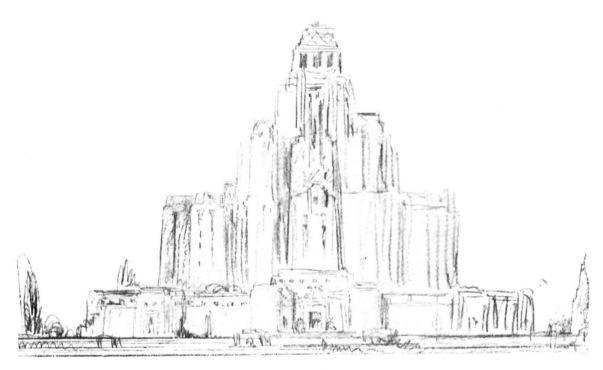

SKETCH

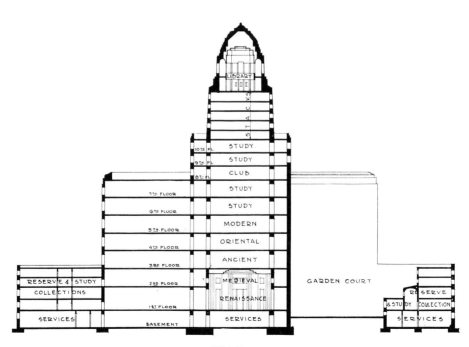

SECTION

latter would be available in the tower and at the periphery of the monumental base, while a limited number of the museum's choicest objects, shown in the period settings that had become increasingly popular, were to be located in the spokes of the wheel-like plan. In looking to the technology of the commercial skyscraper, Stein revealed an impatience with conventional prototypes that was becoming characteristic of the time. But his project retains the heavy walls and ponderous classical forms of traditional architecture, and it would take a revolution from a radically different direction to overcome the hold of the "marble halls."

Modern Architecture Comes to the Art Museum, 1932–1960

Despite the economic crisis, the 1930s were fateful years for the American art museum. Its mission would be extended into new territories and its architectural image drastically reshaped, in good measure thanks to the leadership of the Museum of Modern Art in New York City, founded in 1929. Guided by its inspired first director, Alfred H. Barr, Jr., the Museum of Modern Art brought hitherto neglected art forms, such as photography, motion pictures, and contemporary industrial design, into the Muses' sacred grove. Its inexpensively mounted traveling shows not only put Americans throughout the country into contact with the most sophisticated examples of contemporary art, but required the eager recipient museums to set aside space for temporary exhibitions. While its traveling displays were relatively modest compared with today's blockbuster shows, they were important to the formulation of new planning ideas. The Museum of Modern Art pushed the social and cultural activities of the museum further than ever before through lectures, debates, films, radio programs, and a dizzying round of chic and eventful openings.

The Museum of Modern Art was an aggressive tastemaker and, by encouraging Americans to accept abstraction as formulated by the European avant-garde, had a powerful impact on the arts, particularly architecture.[20] In 1932, its "International Exhibition: Modern Architecture" opened, and subsequently toured the country, introducing to the United States that orthodox version of modern architecture which came to be called the International Style. The museum, as every other building type, would be transfigured by this vision of the new, the good, and the beautiful.

The first realization of this vision in terms of the museum is the interior of the Avery Memorial Wing of the Wadsworth Atheneum

of 1932–34 (Fig. 42). The architects, Benjamin Wistar Morris (1870–1944) and his partner, Robert T. O'Connor, worked closely with the director, C. Everett "Chick" Austen, to design an addition which would support the busy schedule of concerts, plays, traveling exhibitions, and children's activities that the Atheneum embarked on during Austen's stewardship. Like Barr, Austen was a promoter of the avant-garde—the world premiere of the opera *Four Saints in Three Acts,* by Virgil Thomson and Gertrude Stein, was held in the auditorium of the Avery Wing—and he made certain that the offices and public spaces of the new addition exemplified the most up-to-date interior design.

The masonry exterior of the Avery Wing had to conform stylistically to an earlier addition and is thus *moderne* rather than modernist,[21] but the court, with its theatrically cantilevered balconies, seems in sharp contrast to its siblings from the years 1893 to 1932 (see Figs. 28, 36, 39). Nevertheless, in its *parti* the tradition of peripheral exhibition spaces around a top-lighted central area is maintained, although there is a *double* circuit of galleries which offers greater flexibility. The sense of novelty, therefore, stems chiefly from the replacement of the forbidden pleasures of ornament and historical allusion by the structural drama of the hovering balconies.

It would be in the Museum of Modern Art's own new headquarters, completed in 1939,[22] that the full range of modernist assumptions was tested. In the building by Philip Goodwin (1885–1958) and Edward Durrell Stone (1902–1978), the entire conception of what was suitable for circulation and exhibition spaces has been altered. Formal axes, grand corridors, and fixed galleries are abandoned for loft-like floors that can be partitioned to resemble the New York apartments of typical Museum of Modern Art donors, a format that has been retained in the renovation and addition currently under construction (see pp. 78–85). The court is not enclosed but moved outside, to the rear, to become a sculpture garden. Although the six-story building is not exactly a skyscraper, it does have elevators and transgresses the height restrictions of the conventional museum. It reaches upward within a tight urban matrix rather than extending outward in a park-like setting, and may be justly considered the archetypal cosmopolitan art museum.

The architects have followed the principles of the International Style enunciated in 1932: architecture as volume, not mass; regularity but not symmetry; reliance for aesthetic satisfaction on the intrinsic quality of elegant materials, fine proportions, and technical perfection rather than applied ornament.[23] The façade is obviously a non-load-bearing skin, stretched over the structure. The recessed ground

Fig. 42. Avery
Memorial Wing,
Wadsworth Athe-
neum, Hartford,
Connecticut. Morris
and O'Connor,
1932–34. Court.

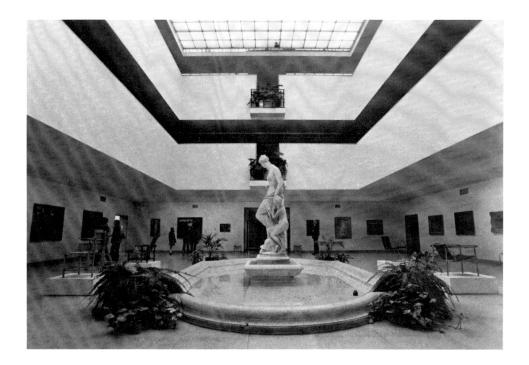

story and the strip windows declare the weightlessness of the frontal
plane, divided into transparent, opaque and translucent rectangles.
The translucent area is a large, "thermolux" window into which can
be inserted opaque asbestos panels to control the quantity of natural
light admitted to the second- and third-floor galleries.

By the time of its opening, modernist preoccupations had been
absorbed so thoroughly that the Museum of Modern Art's building
would have seemed daring only in contrast to the project by the great
classicist John Russell Pope (1874–1937) for the National Gallery of
Art in Washington, D.C. (Fig. 32), which was completed in 1941.[24]
Far more intrepid, and regrettably far less practical, were two other
designs of this period which ever since have stirred the imaginations
and nagged the consciences of architects and museum personnel who
have sought to temper the vices of these projects and rejoice in their
virtues. Although both projects challenged received wisdom about
museum design, they were poles apart.

The proposal of 1942 by Ludwig Mies van der Rohe (1886–1969) for
a "Museum for a Small City" (Figs. 43–45) pushes to its outer limits
the modernist repudiation of typological representation; only the
objects it shelters give a clue to the building's purpose. The design is
born of Mies' obsession with universal space articulated by a

Right:
Fig. 43. Ludwig
Mies van der Rohe,
"Museum for a
Small City," 1942.
Plan. (The Museum
of Modern Art, New
York; Mies van der
Rohe Collection.)

Below:
Fig. 44. Exterior.
(Whereabouts of
drawing unknown.)

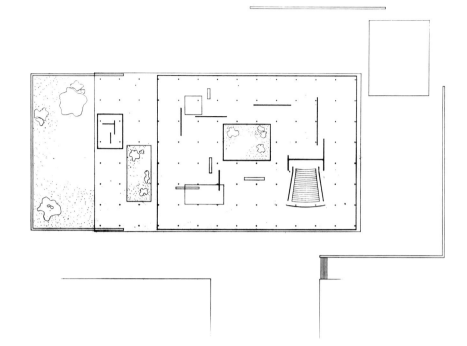

Fig. 45. "Museum for a Small City." Interior. (The Museum of Modern Art, New York; Mies van der Rohe Collection.)

structural grid of machine-like perfection, no less than of his involvement with such revolutionary art movements as de Stijl and Constructivism. Only the rectangles of roof and floor establish visual boundaries. The walls are of glass and therefore the paintings themselves become the planes that define the nonhierarchical space. Mies applied this system to almost every building type, from the house to the office building, and its suitability to art museums can certainly be questioned. Nevertheless the "Museum without Walls," and the freedom it gives—indeed forces upon—the curator to shape the interior volume as he designs the installation, has remained a tantalizing conceit.

The other project, first broached in 1943 but realized only in 1959, is the Solomon R. Guggenheim Museum in New York City (Figs.

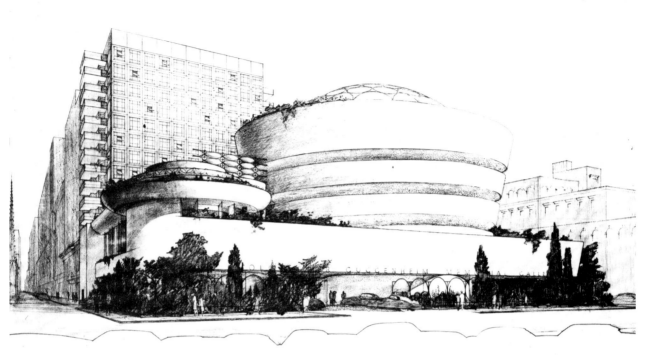

THE MODERN GALLERY
MUSEUM FOR THE SOLOMON R GUGGENHEIM FOUNDATION
FRANK LLOYD WRIGHT ARCHITECT
HOLDEN AND McLAUGHLIN ASSOCIATES

Above:
Fig. 46. The Solomon R. Guggenheim Museum, New York. Frank Lloyd Wright, 1943–59. Exterior; drawing by the architect, signed and dated August 5, 1951. (The Frank Lloyd Wright Foundation.)

Right:
Fig. 47. Interior, drawing by the architect. (The Frank Lloyd Wright Foundation.)

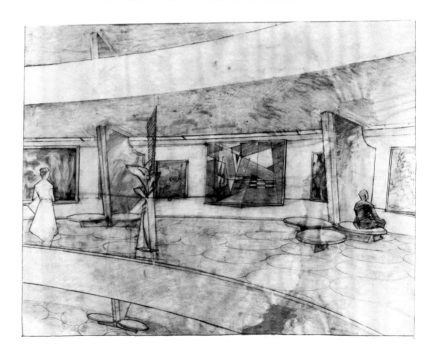

Fig. 48. The Solomon R. Guggenheim Museum. Interior.

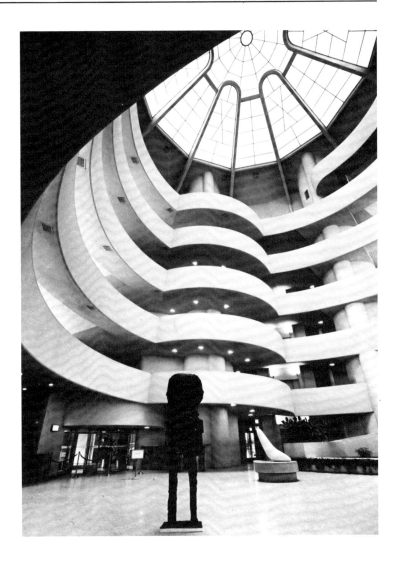

46–48) by Frank Lloyd Wright (1867–1959). In contrast to Mies' design, the space is visually contained and made palpable, a majestic volume around which the galleries spin. For all his inventiveness, Wright has not been too proud to reach back in time and acknowledge the art museum's original heart, the domed rotunda (see Fig. 8), which he has expanded so that it dominates the whole organism. The spiraling ramp, which serves both circulation and exhibition, allows viewing up close and across the void, standing and in motion. The museum is conceived principally for temporary shows of comfortable size.

It would be pointless to reiterate here the paeans of praise and cries of outrage that this building has elicited since its opening a few months after Wright's death, to review the alterations it has under-

gone in the name of function, to cavil at the coarseness of the execution, or to deplore the design's hostility to the city's grid.[25] Suffice it to say that the writer, in her persona as avid museumgoer, has always found it splendid, as have many architects.

The Guggenheim had no immediate progeny, but the idea of a ramp-rimmed atrium is echoed in two projects in this exhibition (see pp. 92–97, 106–13). Furthermore, Wright's controversial building stimulated a trend in museum architecture toward a readily identifiable image for each institution. But that trend was countered by an equally strong inclination to refine the idea set forth in the "Museum for a Small City." Mies himself worked at this perpetually, eventually eliminating the interior columns altogether to achieve his "ideal museum . . . one large area, allowing complete flexibility; architectural space in such a museum becomes . . . defining rather than confining."[26] His additions to the Museum of Fine Arts in Houston—Cullinan Hall of 1958–63, and the Brown Pavilion, completed in 1973,[27] which has an 83-by-300-foot gallery totally free of interior walls and columns—are perfected versions of his scheme of 1942, as is his Neue Nationalgalerie in Berlin, of 1962–68. Other architects as well would find the glasshouse aesthetic irresistible, but it would remain just one approach to contemporary museum design.

The Last Two Decades: Strongbox or Greenhouse

Surveying museum construction of the 1960s and early 1970s, the critic Paul Goldberger observed:

> If the museums are the keys to what our communities value . . . they present a confused picture of the American community right now. . . . There is little in the way of a consistent philosophy, either of museum management or of architecture that one can glean from this potpourri [of museum designs].[28]

Goldberger was reacting to an anarchic architectural scene characterized by disenchantment with an International Style grown official and stodgy. People were ready for a change, although uncertain what direction the change should take.

One impulse was to maintain the geometric modernist container but to invigorate its surfaces through the revelation, actual or symbolic, of structure. Such a gesture informs the Sheldon Memorial Art Gallery at the University of Nebraska in Lincoln, completed in 1963 (Figs. 49–51). The architect was Philip Johnson (b. 1906), already experienced in museum design through his early post as architectural curator at the Museum of Modern Art and subsequent commissions

Ground floor

Second floor

Right:
Fig. 49. Sheldon Memorial Art Gallery, University of Nebraska, Lincoln. Philip Johnson, 1963. Plans.

Below:
Fig. 50. Exterior.

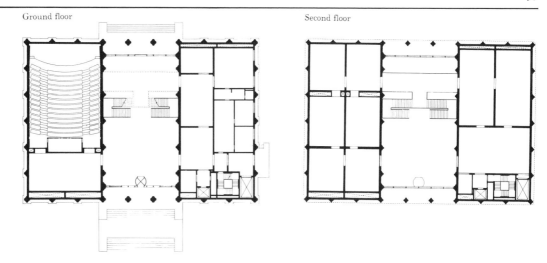

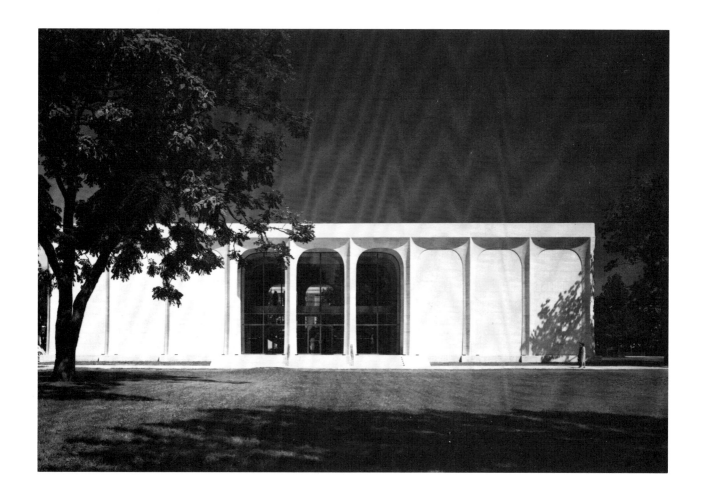

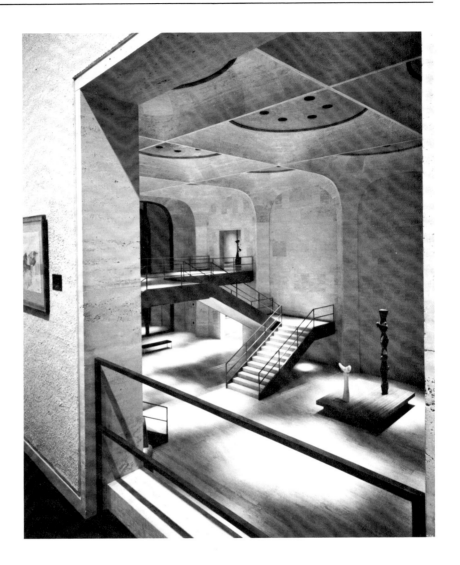

in New York City, Utica, and Fort Worth.[29] He would go on to
design a number of other public museums as well as experiment in
New Canaan, Connecticut, with galleries for his own collection, à la
John Soane.

Although the reinforced concrete structural system employed at
Lincoln would have permitted a universal space of the Miesian type,
Johnson opted instead for a more traditional *parti* of central hall
flanked by galleries that are not fluid spaces but fixed in dimension
and shape. Initially a champion of the International Style, Johnson
eventually was repelled by its total rejection of history. Thus the two-
story "colonnade" and the travertine cladding (covering skin) forge
visual links with the Altes Museum, and the axial plan, with its
stately stairhall sculpture court, alludes to familiar "marble halls." A

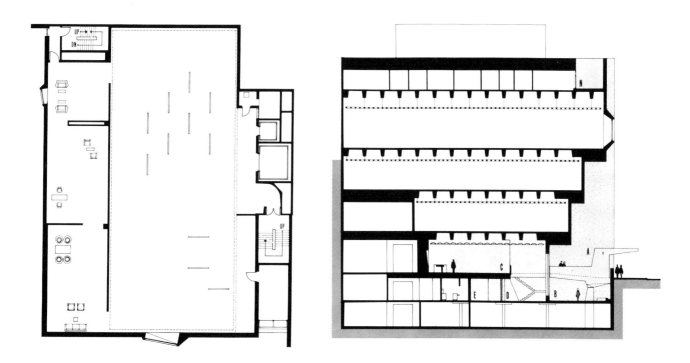

Above, left:
Fig. 52. Whitney Museum of American Art, New York. Marcel Breuer and Hamilton Smith, 1963–66. Plan of fourth floor.

Above, right:
Fig. 53. Section.

powerful arbiter of architectural fashion, Johnson in the Sheldon Memorial Art Gallery set the stage for that embrace of historical allusion which is so pervasive at the present moment.

Probably the major trend to affect art museum architecture in these years was Brutalism, a style that evolved in the late 1950s as an antidote to the sleek and elegantly detailed rectangular packages that had come to house establishment institutions. Brutalist buildings were sculptural rather than planar, aggressive rather than well behaved. There can surely be no more telling comparison to illustrate the dramatic change from International Style to Brutalism than that between the Museum of Modern Art's original building and the permanent home of the Whitney Museum of American Art, of 1963–66 (Figs. 52–54), by Marcel Breuer (1902–1981) and Hamilton Smith.[30]

Like the Museum of Modern Art, the Whitney provides a vertical stack of loft-like spaces that are extremely flexible, although for variety's sake there are also some room-like galleries on the northern side of the building. But where the Museum of Modern Art inside and out gives the impression of lightness and smoothness, the Whitney is dark, heavy and richly textured. The suspended precast concrete ceiling accommodates movable wall panels and plug-in

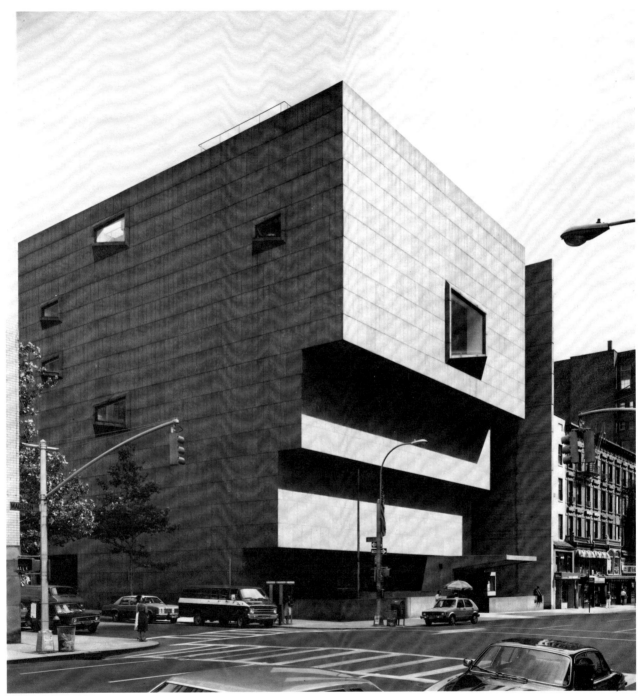

Fig. 54. Whitney
Museum of Amer-
ican Art. Exterior.

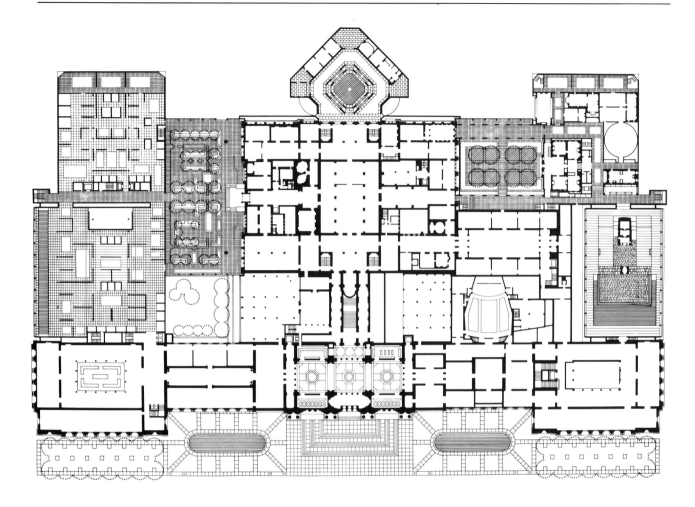

Fig. 55. The Metropolitan Museum of Art, New York. Master plan showing original buildings and additions by Kevin Roche John Dinkeloo and Associates, 1967–81.

lighting fixtures, and conceals utilities; its three-dimensional character is typically Brutalist. Exigencies of site placed the sculpture garden in a sunken plaza that entices passing pedestrians to enter the museum, the intention also of the eccentric windows, so often found in Brutalist buildings. The dark gray granite cladding attests to the rejection, common in this period, of the monolithic whiteness of orthodox modernism.

The Brutalists' interest in shape making is shared by the practitioners of what might be dubbed the Greenhouse Aesthetic. But instead of dealing with plastic masses, the emphasis is on meticulously detailed transparent skins, and rather than relying on artificial illumination the stress is on abundant natural light. In the museum field the most conspicuous practitioners of the Greenhouse Aesthetic are Kevin Roche (b. 1922) and John Dinkeloo (1918–1981), since 1967 the master planners for the Metropolitan Museum of Art in New York

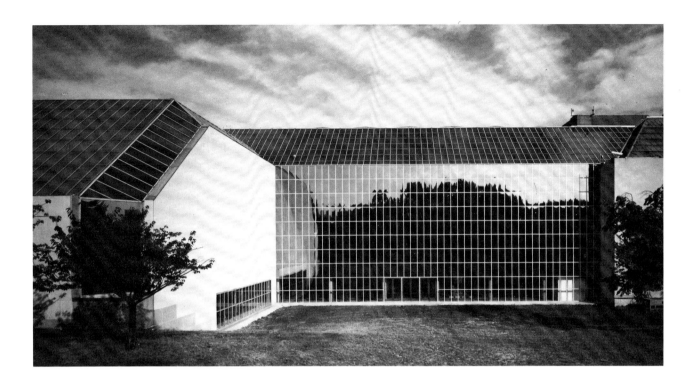

City (Figs. 55–57). Their fastidious additions had to harmonize with a building that was already the work of many hands. The first, Victorian Gothic structure of 1874–79 by Calvert Vaux (1824–1895) and Jacob Wrey Mould (1825–1884) partially survives, visible in the jewel-like Lehman Pavilion of 1975, while the magnificent Beaux-Arts frontispiece by Richard Morris Hunt (1827–1895) and his son, Richard Howland Hunt (1862–1931), as well as the monumental classical wings by McKim, Mead and White that were sequentially appended during the first three decades of this century,[31] are beautifully set off by the glass surfaces of the new accretions, transparent or reflective in some areas, in others translucent to protect fragile objects from the harmful effects of natural light. The Miesian glass box has been transposed into a Crystal Palace, a class of exposition building that in the nineteenth century frequently served for the display of art no less than manufactures.

The Greenhouse Aesthetic merges with a Brutalism gone refined in the work of I.M. Pei (b. 1917), whose firm has made such an indelible mark on museum design. Pei's addition to the Museum of Fine Arts in Boston (Figs. 58–60), which opened in 1981, shows that many older museums urgently need space for purposes other than exhibition. The area devoted to galleries is only a small part of the total

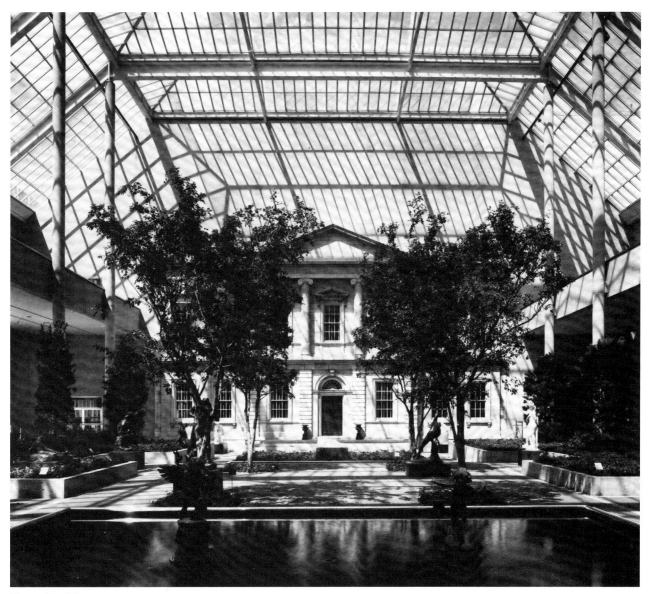

Fig. 57. The Metro-
politan Museum of
Art, American Wing.
Courtyard.

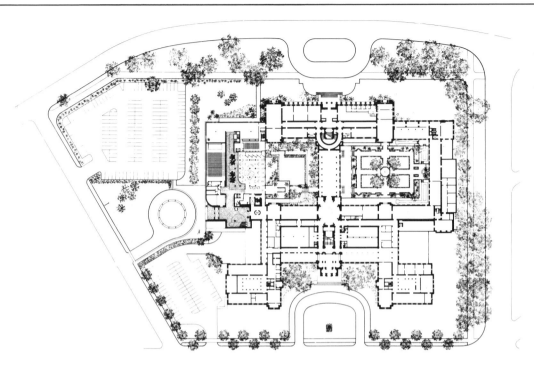

Left:
Fig. 58. Museum of
Fine Arts, Boston.
Master plan showing
original buildings
and West Wing addi-
tion by I.M. Pei,
1977–81.

Below:
Fig. 59. West Wing
addition. Exterior.

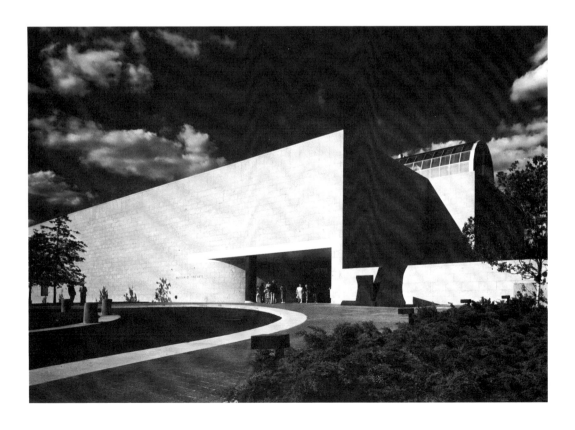

Fig. 60. Museum of Fine Arts, Boston. West Wing addition, Galleria.

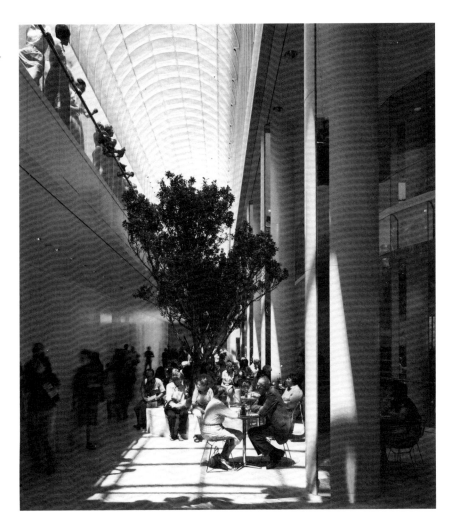

footage of the new wing. Like many of his colleagues, Pei faced the task of adding on to a resoundingly classical monument. While there are echoes of the Crystal Palace in the transparent arch of the Galleria, the finely cut ashlar masonry walls are meant to match the Grecian mood of Guy Lowell's design.

The work of Louis I. Kahn (1901–1974) defies ready classification. His lifelong preoccupation with light in architecture and his belief that the goal of the architect was to translate program into institution made him a patient explorer of the museum venture. In 1969 he was given the opportunity to design the Yale Center for British Art (Figs. 61–63),[32] directly across the street from his first museum, the Yale University Art Gallery of 1951–53. The change in conception from first to last museum design not only allows one to trace Kahn's

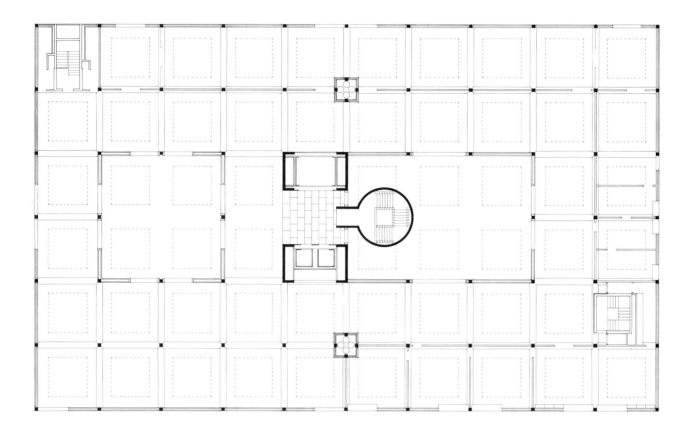

Fig. 61. Yale Center
for British Art, New
Haven, Connecticut.
Louis I. Kahn,
1969–77. Plan of
fourth floor.

personal odyssey, but suggests how much professional opinion
differs with regard to the most functional plan. From the exterior,
both buildings are orderly and box-like, but the open floors of the
Yale University Art Gallery have given way to a more hierarchical
organization of space. While he has recalled the iconic two-court
plan, Kahn has not sacrificed flexibility. The domestically scaled
galleries can be rearranged for each installation via custom-designed
dividers set out along the 20-foot module of the structural bays.
Natural light enters to a degree unusual in this area, through the
windows and the specially fabricated skylights which filter out
ultraviolet rays.

The Yale Center contains not only research facilities and Paul
Mellon's enviable donation of British art, but a group of shops
purveying books, cheese, wine, and art. These are situated at ground
level to either side of the main entrance on the corner of High and
Chapel Streets, which leads to a light-filled court that rises through
the full building height. It is probably the first art museum to share

Fig. 62. Yale Center for British Art. Exterior.

headquarters with independent businesses and thus it establishes an important precedent.

Kahn was noted for his capacity to go beyond conventional wisdom to question the fundamental nature of each commission, but he did not ignore the lessons of the past. Just as in his plan for the Yale Center he married archetypal and iconoclastic solutions, so he blended twentieth-century materials, such as stainless steel, aluminum, and reinforced concrete, with more timeless substances, such as travertine, oak, and linen. In this, his last building, completed in 1977, Kahn attained an ideal balance between today's technical possibilities and history's rich heritage, setting a shining standard for art museums in the 1980s.

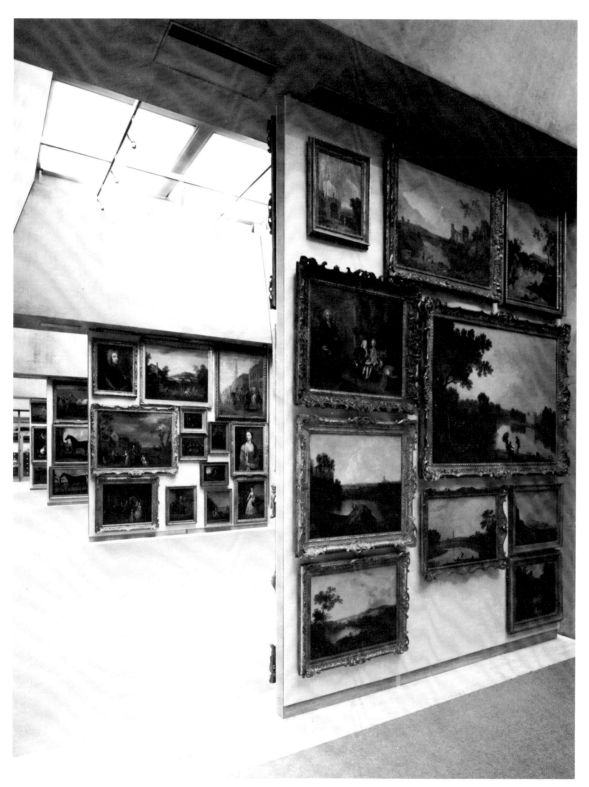

Fig. 63. Yale Center for British Art. Fourth-floor storage galleries.

Notes

1. Galleries for princely and papal collections have existed since the Renaissance and were generally set up in existing palaces. According to Helmut Seling, "The Genesis of the Museum," *The Architectural Review*, 141 (February 1967), pp. 103–14, the first design for a public museum dates from 1704, but this was multipurpose with only a small area set aside for works of art; it was not executed. The Museum Fridericianum in Kassel, of 1769–79, described by Seling as "the first real building designed to be a museum" (p. 104), is nevertheless half devoted to a library. Volker Plagemann, *Das deutsche Kunstmuseum: 1790–1870* (Munich: Prestel-Verlag, 1967), p. 74, gives 1798 as the date for the first plan for an art museum in Germany, and points to its predecessors—the Villa Albani in Rome of the 1760s, erected chiefly to display Cardinal Albani's collection of antiquities, and the Museo Pio-Clementino, a series of galleries added to the Vatican during 1773–86. In Britain most eighteenth-century activity centered on private galleries, and the first home of the varied holdings of the British Museum was the remodeled Montague House (1759); see J.M. Crook, *The British Museum* (Harmondsworth, England: Penguin Books, 1972). The first public art museum in France was opened in the Louvre in 1792, but as early as 1753 the French Academy of Architecture had chosen for one of its *grand prix* projects "an art gallery attached to a palace," and in 1779 a detached museum was the competition subject.

2. Durand's two major publications were *Recueil et parallèle des édifices en tout genre, anciens et modernes*, printed in Paris in 1800, and the two volumes of *Précis des leçons d'architecture*, which appeared in 1802 and 1805.

3. Henry-Russell Hitchcock, *Early Museum Architecture, 1770–1850*, exhibition pamphlet (Hartford, Conn.: Wadsworth Atheneum, 1934), n.p., mistakenly dismissed this claim on the grounds that the Academy was an art school rather than a museum. In fact, all the space in this building, except for a director's room and a porter's lodge, was given over to display, and the Academy did not set up an art school until 1813. George B. Tatum, *Penn's Great Town: 250 Years of Philadelphia Architecture* (Philadelphia: University of Pennsylvania Press, 1961), p. 56, believes it to be "the first art museum in America [and] one of the first buildings in the world erected specifically for this purpose." The March 1982 number of *Antiques* is devoted to the Academy buildings.

4. Other art academies were founded after the Pennsylvania Academy but exhibitions were a less important part of their mission and the buildings they occupied could hardly be classified as art museums. For an account of such institutions of art in New York City, see Winifred Howe, *A History of the Metropolitan Museum of Art* (New York: The Metropolitan Museum of Art, 1913), vol. 1, pp. 1–93.

5. See Theodore Sizer, "John Trumbull, Museum Architect," *The Walpole Society Note Book*, 1940, pp. 19–34, a paper read to the 30th Annual Meeting of the Walpole Society on May 18, 1940; and Theodore Sizer, "John Trumbull, Amateur Architect," *Journal of the Society of Architectural Historians*, 8 (July 1949), pp. 1–6. According to Irma Jaffe, *John Trumbull, Patriot-Artist of the American Revolution* (Boston: New York Graphic Society, 1975), p. 278, Trumbull modified a design made at his request by Ithiel Town and Alexander Jackson Davis. But the Greek Doric temple proposed in the watercolor they submitted (Jaffe, fig. 187) was so transformed by Trumbull as to constitute a new building.

6. Cecil Brewer, "American Museum Buildings," *Journal of the Royal Institute of British Architects*, 3rd series, 20 (April 1913), p. 372, noted that in the United States "the lighting is almost universally from the top, very generally by skylights with a flat lay or ceiling light extending over almost the whole of the room."

7. The drawing, in the collection of the New-York Historical Society, is undated, but from its austere classicism, it clearly was executed early in Davis' career; he would move by 1833 ever closer to Picturesque medievalism. Sizer, "John Trumbull, Museum Architect," mentions another drawing by Davis in the New-York Historical Society, inscribed "Pinacotheca for Col. T's Paintings." He describes the project as a Greek Doric temple and dates it 1830. The sheet cannot be located at the New-York Historical Society. It may be the watercolor reproduced by Jaffe (see note 5, above), inscribed "Design: A Pinacotheka for Col. Trumbull's Paintings / Town and Davis Arch^ts," in the Benjamin Franklin Collection, Yale University Library.

8. Henry-Russell Hitchcock, *Modern Architecture: Romanticism and Reintegration* (New York: Payson and Clarke, 1929; reprint, New York: Hacker Art Books, 1970), p. 6, makes the useful distinction between eclecticism of taste—different styles used contemporaneously, but each building all in one style—and eclecticism of style—features of different styles used together on one building.

9. See Sarah Bradford Landau, *P.B. Wight: Architect, Contractor and Critic*, exhibition catalogue (Chicago: The Art Institute of Chicago, 1981), pp. 21–23.

10. See James F. O'Gorman, *The Architecture of Frank Furness*, exhibition catalogue (Philadelphia: Philadelphia Museum of Art, 1973), pp. 34–39.

11. Reference is made to Robert Venturi (b. 1925), whose preference for elements which are "hybrid rather than 'pure,' distorted rather than 'straightforward,'" would surely have been shared by Furness. See Robert Venturi, *Complexity and Contradiction in Architecture* (New York: The Museum of Modern Art, 1966), pp. 22–23.

12. See Margaret Henderson Floyd, "A Terra-Cotta Cornerstone for Copley Square: Museum of Fine Arts, Boston, 1870–1876, by Sturgis and Brigham," *Journal of the Society of Architectural Historians*, 32 (May 1973), pp. 83–103.

13. See John Maass, "Memorial Hall 1876: International Architecture in the First Age of Mass Communications," *Architectura*, 2 (1972), pp. 127–52.

14. Brewer, "American Museum Buildings," p. 365.

15. E.E. Newport, "The New Corcoran Gallery at Washington," *The Illustrated American*, September 26, 1896, p. 426. I am grateful to Katherine Kovacs, archivist of the Corcoran, for this reference.

16. See Samuel D. Warren, "The New Museum," *Museum of Fine Arts Bulletin*, 5 (June 1907), p. 28.

17. J. Randolph Coolidge, Jr., "The Architectural Scheme," *Museum of Fine Arts Bulletin*, 5 (June 1907), p. 41.

18. Lee Simonson, "Skyscrapers for Art Museums," *The American Mercury*, May 1927, pp. 399–403.

19. Clarence Stein, "The Art Museum of Tomorrow," *The Architectural Record*, 67 (January 1930), pp. 5–12.

20. The February 1982 issue of *Progressive Architecture* is devoted to the exhibition and to the Museum of Modern Art's role as promoter of modernism; see the articles therein by Helen Searing, Robert A.M. Stern, and Richard Guy Wilson.

21. In recent years, as it has become clear that modern architecture in fact was much more varied in its physiognomy than it appeared in 1932 at the Museum of Modern Art, the term "modernist" has come into use, to designate that branch which also goes by the name International Style.

22. See Henry-Russell Hitchcock and Philip Johnson, *The International Style: Architecture Since 1922* (New York: W.W. Norton & Company, 1932; second edition, 1966).

23. See Talbot Hamlin, "Modern Display for Works of Art," *Pencil Points*, 20 (September 1939), pp. 615–20; and "The Museum of Modern Art," *The Architectural Forum*, 71 (August 1939), pp. 116–28.

24. For a scathing modernist attack on classicism as represented in the National Gallery, see Joseph Hudnut, "The Last of the Romans," *The Magazine of Art*, 34 (April 1941), pp. 169–73. For a fascinating comparison of Pope's design for the National Gallery with that by Eliel and Eero Saarinen for the Smithsonian Gallery of Art, also in Washington, D.C., but never executed, see Lorimer Rich, "A Study in Contrasts," *Pencil Points*, 22 (August 1941), pp. 497–500. Both periodicals provide good illustrations of Pope's building.

25. The design came in for criticism from the moment it was published in 1945. And as late as 1956, an editorial by Hilton Kramer appeared in *Arts*, exhorting the trustees to reject the scheme, followed by an unsolicited letter from 21 artists supporting the editorial (*Arts*, 30 [June 1956], p. 11; 31 [January 1957], p. 4). The signatories, who included Milton Avery, Willem de Kooning, Adolph Gottlieb, Philip Guston, Franz Kline, Robert Motherwell, and Jack Tworkov, complained that "the basic concept of curvilinear slope . . . indicates a callous disregard for the fundamental rectilinear frame of reference necessary for the adequate visual contemplation of works of art." A sampler of critics' comments was published in *The Architectural Forum*, 111 (December 1959), pp. 93, 180–84, and the building was discussed in every major periodical. Articles of more than routine interest include the following: Edgar Kaufmann, Jr., "The Form of Space for Art," *Art in America*, 46 (Winter 1958–59), pp. 74–77; Lewis Mumford, "The Sky Line: What Wright Hath Wrought," *The New Yorker*, December 5, 1959, pp. 105–64; and Henry-Russell Hitchcock, "Notes of a Traveller: Wright and Kahn," *Zodiac*, 6 (1960), pp. 14–20. Kaufmann and Hitchcock laud the building; Mumford calls it a "mischievous failure" (p. 164). For a discussion of later alterations, see "The Growing Guggenheim," *Art in America*, 53 (June 1965), pp. 25–33.

26. Mies' words, as quoted in "Important New Structure in Houston," *The Connoisseur*, 186 (May 1974), p. 59.

27. See Ann Holmes, "Where More Is Better," *Art News*, 73 (March 1974), pp. 72–73.

28. Paul Goldberger, "What Should a Museum Building Be?," *Art News*, 74 (October 1975), p. 33.

29. The Munson-Williams-Proctor Institute in Utica dates from 1960, the Amon Carter Museum of Western Art in Fort Worth, from 1961. At the Museum of Modern Art, Johnson redesigned the sculpture garden in 1953, and added the East Wing in 1964. Other museums include the Dumbarton Oaks' wing for pre-Columbian art in Washington, D.C., of 1963, and the Kunsthalle in Bielefeld, West Germany, of 1968. He and his partner, John Burgee, were the architects for the Art Museum of South Texas in Corpus Christi of 1972, and the Neuberger Museum of the State University of New York at Purchase, completed in the same year. For the Sheldon Memorial Art Gallery, see the perceptive essay by Henry-Russell Hitchcock, printed in the booklet *The Sheldon Memorial Art Gallery* (Lincoln, Nebr.: Board of Regents, University of Nebraska, 1964), n.p.

30. *Art in America*, 54 (September–October 1966) is largely devoted to the Whitney's new building. See also articles in *The Architectural Forum*, 125 (September 1966), pp. 80–85; and *Progressive Architecture*, 47 (October 1966), pp. 238–41.

31. See Howe, *A History of the Metropolitan Museum of Art*, vol. 1, pp. 113 ff.

32. See Jules David Prown, *The Architecture of the Yale Center for British Art* (New Haven: Yale Center for British Art, 1977).

Art Museums for the 1980s

Introduction

As recently as 1975, who could have foreseen the current art museum explosion? In that year the well-known architectural critic Paul Goldberger unequivocally averred:

> That the great era of museum building is over is, clearly, beyond argument. . . . The boom period that permitted the art rush of the 1960s is not likely to return for some time.*

In fact, the 1980s are charged with excitement for the museumgoer. The seven projects featured here—all either under construction or definitely scheduled to proceed when the final selection was made, in mid-February 1982—represent but a segment of proposed art museum construction. Many other stimulating projects are at various stages in the design process, among them the Anchorage Historical and Fine Arts Museum in Alaska by Mitchell/Giurgola, commissioned early this year; the addition to the J.B. Speed Art Museum in Louisville, Kentucky, by the firm of Geddes Brecher Qualls Cunningham; the Mayer Art Center at Phillips Exeter Academy in New Hampshire by Amsler, Hagenah, MacLean; the Museum of American Folk Art in New York City by Emilio Ambasz; the Menil Collection Museum in Houston by Renzo Piano; and the additions to the Arnot Art Museum in Elmira, New York, by Graham Gund Associates, to the Sheldon Memorial Art Gallery in Lincoln, Nebraska, by Jack Hillberry, and to the Vassar College Art Gallery in Poughkeepsie, New York, by Michael Graves. Three of the four Pritzker Prize-winning architects are currently involved with new American museum designs—Philip Johnson, whose Dade County Cultural Center in Miami will include an exhibition gallery; Kevin Roche, who is designing the Wallace Decorative Arts Gallery in

*Paul Goldberger, "What Should a Museum Building Be?," *Art News*, 74 (October 1975), p. 37.

Williamsburg, Virginia; and James Stirling of England, whose on-again, off-again Fogg Art Museum addition now is going forward—and the distinguished Japanese architect Arato Isozaki has been commissioned to design the new Museum of Contemporary Art in Los Angeles.

Each of these designs conveys a singular and readily identifiable image, a predictable phenomenon, given the current architectural climate. The diversity inevitably extends to methods of presentation. For those who delight in examining the means by which architects develop and present structural and spatial concepts, the projects offer a rich visual feast.

As in the late nineteenth century, so in the late twentieth, coherence must be sought not in style but in certain basic concerns, shared by most members of the profession, several of which are illustrated in the current museum designs. Extreme care has been given to crafts-manship and the employment of materials so that each of the projects, when executed, will have a distinctly sensual impact. Furthermore, in most of the designs, whether for new structures or for additions to existing ones, the architects have taken pains to respect the existing physical context and to reinforce the museum's role as an active participant in its community. While in itself this practice encourages formal and textural differentiation, it also forges a theoretical link among the projects.

There is, moreover, accord on the issues that are of crucial impor-tance to museums. The tendency to provide a significant amount of natural light, which emerged in the 1970s, has been sustained, in contrast to the overwhelming preference for artificial illumination

typical of the 1950s and 1960s. Another common element is that the circulation patterns devised by the architects, while still affording the visitor a degree of choice, are not so fluid and random as they were when loft-type spaces were the rule. The contemporary approach to circulation provides a greater sense of direction and formal order. There is usually independent access to the various facilities so that programs which take place outside the standard museum hours can be accommodated.

Few commissions are as challenging as those for art museums. The special problems relating to mechanical services, security, and movement must appear to be solved effortlessly, so that the solutions themselves do not obtrude on the works of art. To further complicate the architect's task, museums have constituencies with differing, if not conflicting, desires. Finally, there has been a long-standing controversy about the proper nature of art museum architecture. It has often been maintained that the building should be merely an efficient and self-effacing warehouse, a *machine à exposer*; conversely it has been argued that the museum structure itself should make a positive architectural statement and express that interplay between personal artistic vision and communal needs inherent in the very meaning of architecture. To judge from the current crop of projects, the view that the art museum building should resoundingly proclaim the state of the art of architecture is at this moment ascendant.

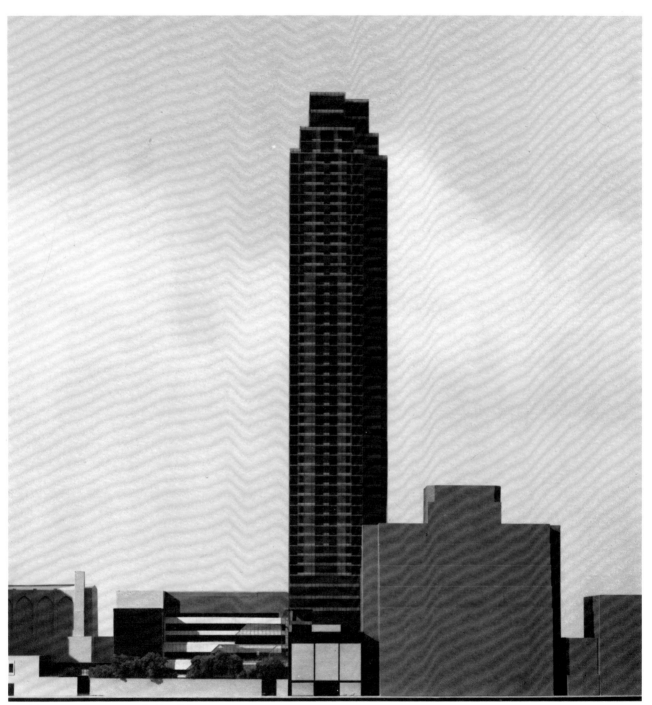

Model. Exterior from West Fifty-fourth Street.

The Museum of Modern Art
New York, New York
Gallery Expansion and Residential Tower

Architects
Cesar Pelli & Associates, Design Architect
Gruen Associates, P.C., Architect for the Museum
Edward Durrell Stone Associates,
Architect for the Residential Tower

Client
The Museum of Modern Art/Trust for Cultural Resources of the City of New York

Date of Commission
January 1977

Expected Date of Completion
Fall 1983

Program and Nature of the Collection
Museum renovation and expansion project: 168,000 square feet of new space; 203,000 square feet of renovated space. Doubling of the existing gallery space from 40,550 square feet to 87,000 square feet, of which 16,250 square feet is for temporary exhibitions, and 70,750 square feet for the permanent collection. In addition, there are two restaurants, a new 223-seat auditorium, a new bookstore, and a 30 percent increase in office and service space. The 53-story building includes a Residential Tower with 500,000 gross square feet of apartments.

Founded in 1929 with the stated purpose of encouraging and developing the "study of the modern arts and the applications of such arts to manufacture and practical life," the Museum of Modern Art's first intention was "to establish a collection of the immediate ancestors of the modern movement . . . and the most important living masters" by means of "gifts, bequests, purchases and semi-permanent loans." In addition to an actively growing collection of painting, sculpture, and the graphic arts, the museum has holdings in the areas of photography, industrial and theatre design, architecture, and film. The earliest works date from the 1870s, but the mandate to collect the work of "the most important living masters" means that an open-ended collection must be preserved and exhibited.

Site and Context
Midtown Manhattan, Fifty-third and Fifty-fourth Streets between Fifth and Sixth Avenues. Surrounding buildings have different uses: commercial (offices, shops, restaurants), residential, and institutional (St. Thomas Church by Bertram G. Goodhue, the Museum of American Folk Art, the American Craft Museum).

Director's Statement

In the two decades since its last major expansion, the Museum of Modern Art's need for additional space has grown increasingly acute. Only a fraction of its growing collections could be concurrently on view in its galleries, and spaces formerly available for special exhibitions had to be reallocated to show even a modest representation of recent acquisitions of contemporary art. Similarly, lobby areas, elevators, and other public facilities were very severely strained by the growing number of visitors who came for major exhibitions or simply to view the collections on weekends.

The need to expand the museum was obvious to all, and a number of alternative plans were proposed for consideration. At the same time, however, the costs of serving a larger public and the impact of inflation were producing substan-

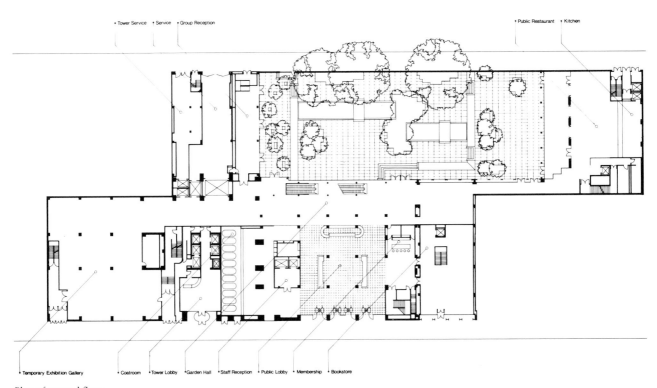

• Tower Service • Service • Group Reception • Public Restaurant • Kitchen

• Temporary Exhibition Gallery • Coatroom • Tower Lobby • Garden Hall • Staff Reception • Public Lobby • Membership • Bookstore

Plan of ground floor.

tial annual deficits. Major new construction could not responsibly be undertaken without provision for new sources of income to support operations of expanded facilities in the future. The solution to this dilemma was an imaginative and innovative plan to realize the value of a frozen asset of the museum: the air rights over its prime location in midtown Manhattan.

Under the aegis of the Trust for Cultural Resources of the City of New York, this plan was carried out with the sale of the air rights for the then record price of $17 million

to a private developer, who would then construct a condominium-apartment tower over a new museum wing to the west of its existing buildings. Through the Trust, the museum would also receive the benefit of the city real estate taxes produced by the new apartment building. A third essential element of the financing plan was a 50th anniversary capital campaign with an eventual goal of $75 million to provide additional endowment funds after construction costs were covered.

With these commitments in place,

the museum was able to proceed with the exciting architectural design developed in the meantime by Cesar Pelli & Associates. This design responded both practically and elegantly to the museum's primary goals: to provide on a constricted site the maximum additional space for exhibition of art and for other basic museum functions; to provide adequately for reception, circulation, and general accommodation of its visitors, already more than a million annually and likely to increase in the future; to accomplish these purposes without sacrificing special qualities for which the museum has

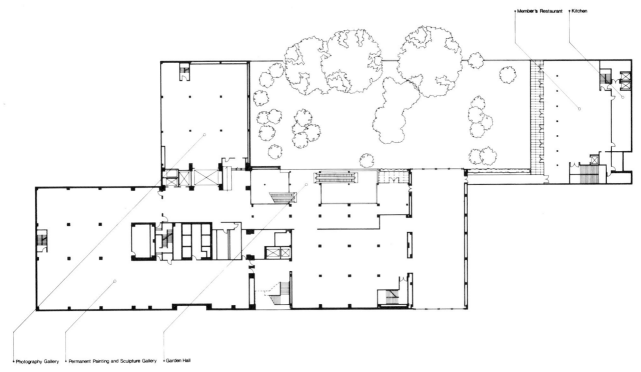

Member's Restaurant Kitchen

Photography Gallery Permanent Painting and Sculpture Gallery Garden Hall

Plan of second floor.

been appreciated in the past: the pleasures of its Sculpture Garden and a sense of intimacy with works on view because its galleries have been neither daunting in scale nor exhausting in number.

We are confident that the design of the expanded museum admirably meets these purposes. With great anticipation we look forward to the fulfillment in 1983 of the hopes which so many friends of the museum have worked long and faithfully to realize.
—*Richard E. Oldenburg*

Architect's Statement

The Museum of Modern Art's expansion project has required the balancing of many physical, cultural, and economic givens. The first task was to understand the complex reality of the project in order to discover its potential for creative design. We had to design a major expansion for a world-class museum on an extremely tight plot within a limited budget. Every item was evaluated by the museum and its staff. We also had to work within the strong and healthy traditions of the Museum of Modern Art about exhibition spaces

and interior architectural character.

Another physical constraint, arising not from the past but from present needs, was the requirement of placing an apartment tower on the site. The structure of the tower and its central core (with its elevators, stairways, and mechanical shafts) had to go through the new wing of the museum and therefore limited the spatial arrangements of the new galleries. The tower was positioned to avoid the existing buildings and minimize its impact on the Sculpture Garden.

Our design had to be based on the

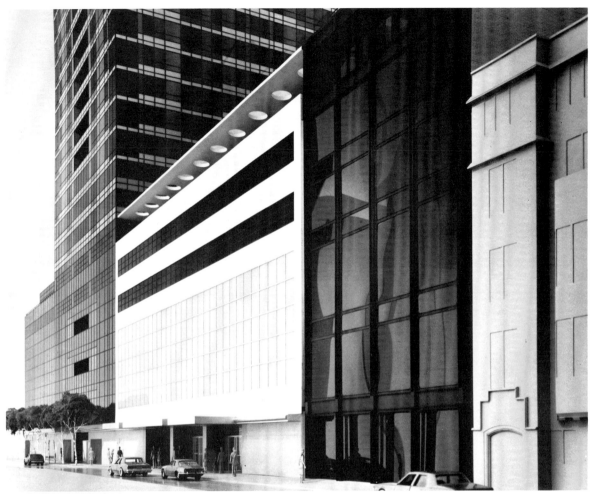

Model. Exterior from West Fifty-third Street.

traditions of the Museum of Modern Art, which has very well-defined attitudes toward the exhibition of art, requiring that paintings be shown under incandescent light, that they be seen in rooms of moderate size, and that they be hung on plain, white walls where each painting can be seen as an individual object. The collection is arranged stylistically in support of the museum's didactic goals.

Most museums of contemporary art are built ahead of their collections. At the Museum of Modern Art, the collection is so extensive that even

with our expansion the museum will have many more paintings than it will be able to show at one time. The expansion will make possible the permanent display of at least one-third of the collection (compared with one-sixth up to now).

The most significant change is in building type, resulting from the growing holdings and a dramatic increase in the number of visitors. The building of 1939 was conceived as a large house. The entrance was through a small and comfortable lobby that led to the upstairs rooms via a stair and a pair of elevators. In

1964, Philip Johnson converted the casual corner entrance of the house into a formal central vestibule capable of handling the crowds that were already beginning to visit. He altered the character of the entrance and its relationship with the garden, but the organization of the museum remained the same.

Our present addition responds to a new set of conditions. The Museum of Modern Art has become a popular institution that everyone wants to visit. The Sculpture Garden is no longer a private backyard. Since 1953 it has been one of New York

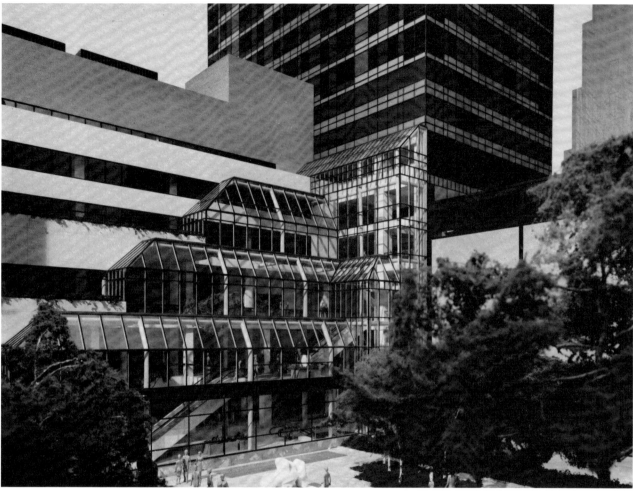

Model. Exterior of Garden Hall.

City's most special and beautiful spaces. The increased attendance and the growth of the collection have created a need for additional space, and have forced us to restructure the old buildings to work as one with the new. They must now function to accept large crowds. The flow will no longer move from point to point vertically; the emphasis now is on horizontal movement from east to west. The building length has doubled (to 353 feet on Fifty-third Street) but the number of floors has not increased. We were able to accomplish most of our objectives by the creation of the Garden Hall, a light, transparent attachment containing the escalators so essential for accommodating the projected increase in traffic and moving people easily from floor to floor. It also contains the east-to-west circulation that bypasses the fixed vertical elements of the original building at 11 West Fifty-third Street.

The collection is now large enough to require longer visits and an occasional change of environment will be necessary just to unglaze the visitor's eyes. With the Garden Hall, we have been able to change the spatial experience while maintaining the traditional character of the galleries. To go from one floor to another, the visitor will have to move through the Garden Hall, a light and airy place with a view of the Sculpture Garden, Fifty-fourth Street, and midtown Manhattan. Each department will have an adequate space with enough room not only for the permanent collections but also for temporary exhibitions within its own gallery. There are two very large areas for temporary shows on the ground floor and the lower level. This arrangement allows for a more dynamic presentation of new work

or special shows, for while one is being changed, the other can go on. At the same time, the extended galleries will allow for a more comprehensive display of the permanent collections. Thus in terms of both temporary shows and permanent installations, the museum will be a more interesting and lively place to visit.

The entrance remains as Johnson established it in 1964. With his eastern, and now our western addition, the original building is even more centered in the composition. The symmetrical axis is reinforced by the lobby layout. As you enter and face the Garden, you come immediately to the Garden Hall, which with its escalators becomes the dominant element in circulation. The lobby is much larger, to allow for groups of people to move with ease and comfort from lobby to exhibition space, and from gallery to gallery.

The significant improvement in circulation and an overall upgrading of every operations facility were our objectives. We have tried in every instance to accommodate the museum's needs by turning limitations into advantages and complex circumstances into opportunities for creative design.
—*Cesar Pelli*

Historical Exemplars
The Museum of Modern Art in its various incarnations—remodeled residence at 11 West Fifty-third Street (1932); first new building by Goodwin and Stone (1938–39); additions by Philip Johnson (1953, 1964).

Structure and Materials
Concrete frame, with glass and aluminum curtain wall. Glass is ceramic frit-backed, in custom colors ranging from pale gray to muted cerulean blue. Floor surfaces: Vermont delft marble. Some fixed walls, some movable partition walls finished in plaster.

Lighting
Natural light from the Garden Hall for sculpture and main circulation space; incandescent light for galleries.

Circulation
Escalators enclosed within a glass hall located directly off the entrance lobby. They will convey visitors to galleries on four floors, will contain naturally lighted balconies for sculpture, and will provide extensive views of the Sculpture Garden and beyond.

Construction Cost
$22 million (museum only)

Project Architects
Cesar Pelli, Fred Clarke, Diana Balmori, Tom Morton

Model Maker
Cesar Pelli & Associates

Draftspersons
Malcolm Roberts, Brad Fiske, Tom Soyster, Mark Schlenker, Monique Corbat-Brooks

Contractor
Turner Construction Company

Structural Consultants
Rosenwasser Associates

Lighting Consultant
Donald Bliss

Acoustical Consultants
Cerami and Associates, Inc.

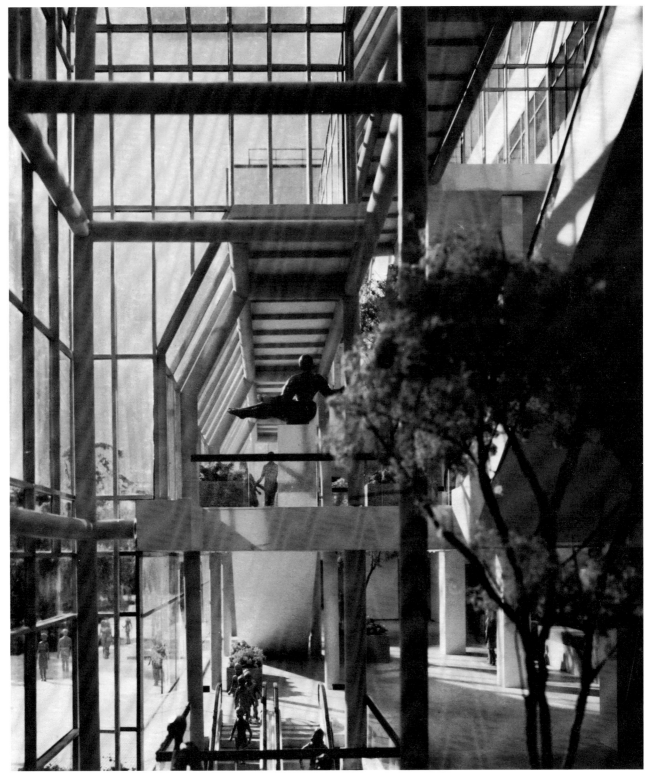

Model. Interior of Garden Hall.

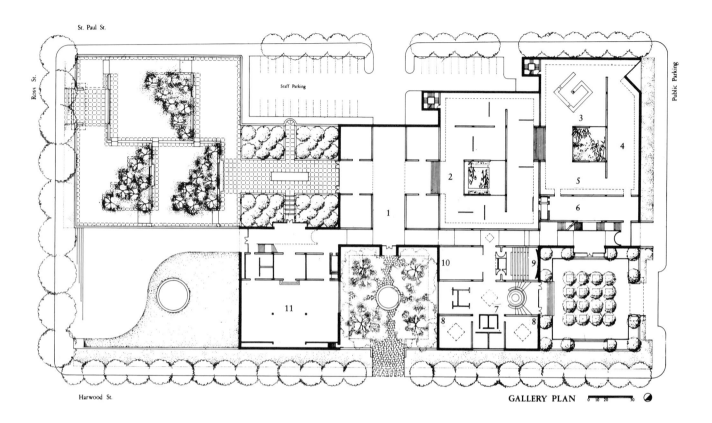

GALLERY PLAN

Plan of gallery level.

Key
1 Contemporary Gallery
2 American & European Art Galleries
3 Pre-Columbian Art
4 African Art
5 Asian Art
6 American Indian & Oceanic Art
7 Children's Education Wing
8 Studio–Classroom
9 Orientation
10 Museum Bookstore
11 Temporary Exhibition Galleries

Dallas Museum of Fine Arts
Dallas, Texas

Architects
Edward Larrabee Barnes Associates, P.C.

Client
Dallas Museum of Fine Arts and the
City of Dallas

Date of Commission
Fall 1977

Expected Date of Completion
Fall 1983

*Program and Nature of the
Collection*
New museum of 193,000 square
feet. The gallery space is 77,000
square feet, of which 10,000 is for
temporary exhibitions and 67,000
for the permanent collection. There
is a 350-seat auditorium, a 100-seat
orientation room, a library, a 250-
seat restaurant, a museum shop, ad-
ministrative and curatorial offices,
studios for art conservation, pho-
tography, and exhibition design, art
studio classrooms, and storage and
work spaces.

The permanent collections demon-
strate a great range, with holdings in
African, Oceanic, North American
Indian and pre-Columbian art. Ori-
ental, ancient Mediterranean, and
European art since the Renaissance
is represented, as is American art of
the nineteenth and twentieth cen-
turies. In addition, the museum has

commissioned Richard Fleischner to
do a site-specific work of art in
collaboration with the architects for
the Education Courtyard.

Site and Context
Downtown Dallas. The museum is
sited to become the western termi-
nus of an axis running through an
adjacent planned "arts district."
Streets have been closed and re-
aligned so that the museum will
have an unbroken eight-acre site
with access from all four sides,
considerable open space, and room
for expansion.

Director's Statement
The new Dallas Museum of Fine
Arts results from a unique part-
nership of public and private initia-
tive. Under a contract with the city
of Dallas, a board of trustees is
responsible for management of the
collection and the facility, both
owned by the city. As interest in the
museum surged in the last decade,
public and private groups together
developed a plan for upgrading the
institution. In a 1979 bond election,
the majority of 60,000 voters autho-
rized the sale of $24.8 million of
general obligation city bonds for

that purpose, making the Dallas
Museum of Fine Arts one of the few
American art museums to be autho-
rized by public referendum. In addi-
tion, more than 1,500 donors have
contributed to the city over $20
million in building funds, and major
art collections have been pledged as
gifts. This is testimony to the grow-
ing sophistication, ambition, and
prosperity of the city of Dallas,
whose competitive spirit has been
spurred by the exemplary Kimbell
Art Museum and Amon Carter Mu-
seum in nearby Fort Worth.

The new Dallas Museum of Fine
Arts, built downtown, is sited to be
convenient to the drive-in local au-
dience and the walk-in audience of
office workers and visitors. The lo-
cation is geographically neutral and
belongs equally to citizens of all the
city's neighborhoods. It is hoped
that the presence of such an institu-
tion will invigorate the downtown
by attracting residential, office, and
retail development, and thus con-
tribute a note of urbanity to a some-
what lifeless core.

The program reflects a commitment
to public service and to the idea that
a museum should be a dynamic edu-
cational force as well as a reposi-

Elevation from Harwood Street.

tory. Thus the building not only houses a diverse permanent collection that is growing rapidly as private art collecting in Dallas mushrooms, but is also a place of communication and learning, a place where professionals can do their research and the public contemplate and experience works of art. In his design, Edward Barnes has clarified and given physical existence both to civic pride and the cultural aspirations of the whole city.
—*Harry S. Parker III*

Architect's Statement

The new home for the Dallas Museum of Fine Arts will be in the inner ring of Dallas, slated to become an "arts district," with museum, symphony hall, and opera house all within walking distance of each other. Despite the downtown setting with high buildings rising all around, this is essentially a low-rise structure with garden courts and patios and top-lighted galleries.

The museum has three entrances, connected by a "spine" hallway gently ramping down the sloping site and providing access to the various activities as well as to the main galleries. All the activities [see *Program*] can be opened or closed on their own schedules, like shops on a street.

It is the galleries of the permanent collection that set the tone of the whole museum. They are arranged on three levels, each with its own character. First, there are the contemporary galleries—cruciform space embracing four box-like rooms. A 45-foot-high white plastered vault crosses the axis of the vista toward the Sculpture Garden.

Model. Bird's-eye view.

The next level contains the collection of European and American art, a serene space with daylighted outer walls, Miesian screens, and a central patio with a wisteria vine and a quiet pool. The third level contains objects in cases and also has some daylighted walls and a patio, here shaded with mesquite. The exit from the third level leads back to the "spine" by way of a grand cascade stair.

The terracing of the museum on three levels gives coherence to the diverse collections. The visitor may progress in either direction, from the bottom up or, chronologically, from the top down, starting with ethnic and ancient art, down through our European heritage, through contemporary work and out to the Sculpture Garden. When the museum expands over the parking area, two more terraces will be added; visitors will take an escalator to the very top and slowly descend five levels back to the entrance.

Flow is as important as form. Certainly progression through a museum has elements of ceremony. There must be a sense of entrance, of logical sequence, of climax, and return. And this progression must be closely related to the art on display. The museum is an architectural composition involving time—the measured unfolding of the collection in quiet, supportive space.

What kind of architecture supports art rather than competes with it? Obviously highly sculptural or overbearing architecture can upstage the art on display. At the same time, anonymous loft space with no relief of any kind can be monotonous. The theory of the Dallas design is that soft, indirect daylight and splashes of daylight from windows

Model. View from Harwood Street (roof removed to show interiors).

and garden courts and patios enhance the works. This kind of punctuation provides a counterpoint by relating art to nature.

Otherwise the architecture is very quiet. The entire exterior including the vault roof is limestone, cut in huge blocks, coursed with deep V-cuts to set off the stepping of the mass.
—*Edward Larrabee Barnes*

Structure and Materials
Structural steel frame with concrete floor slabs on steel decking. Exterior walls: Indiana limestone. Floor sur-faces: exterior paving of limestone, iron-spot brick and granite cobbles; interior floors of limestone, maple, and recessed carpet with stone border. Interior surfaces: limestone or painted gypsum wallboard with plywood backing in exhibition areas. Interior trim: stone, painted hardwood, and painted steel. Exterior door and window frames of stainless steel and extruded coated aluminum.

Lighting
Daylight through shaded interior courtyards and filtered, louvred sky-lights, supplemented by incandescent lighting.

Circulation
Major public spaces are served by a ramped central hall running the length of the building with grand staircases and elevators at each end. Circulation within the galleries connects three levels of the permanent collection.

Construction Cost
$29.6 million

Principal
Edward Larrabee Barnes, F.A.I.A.

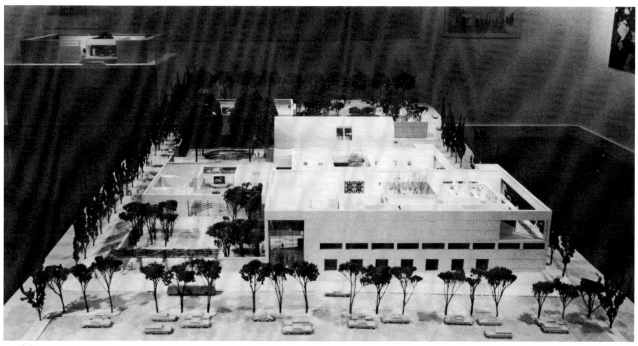

Model. View from public parking area (roof removed to show interiors).

Associate
Alistair Bevington

Project Architect
Daniel T. Casey

Model Makers
Norman Briskman (photos, pp. 89–91)
Aids Models (exhibition)

Renderers
Robin Sen and Shiao-Ling Chang

Graphics
Vignelli Associates

Stone Mockup
Harding and Cogswell

Contractor
J.W. Bateson Company Inc.

Consulting Architects
Pratt Box Henderson and Partners

Structural Engineers
Severud-Perrone-Szegezdy-Sturm

Mechanical Engineers
Joseph R. Loring and Associates

Lighting Consultants
Jules Fisher and Paul Marantz, Inc.

Landscape Architects
Kiley-Walker

*Site Engineering and
Traffic Consultants*
Warren Travers Associates

Security Consultants
Joseph M. Chapman, Inc.

Fountain Consultants
CMS Collaborative

Audio-Visual Consultant
Will Szabo

Acoustical Consultants
Cerami and Associates, Inc.

Food Service
Design Services Ltd.

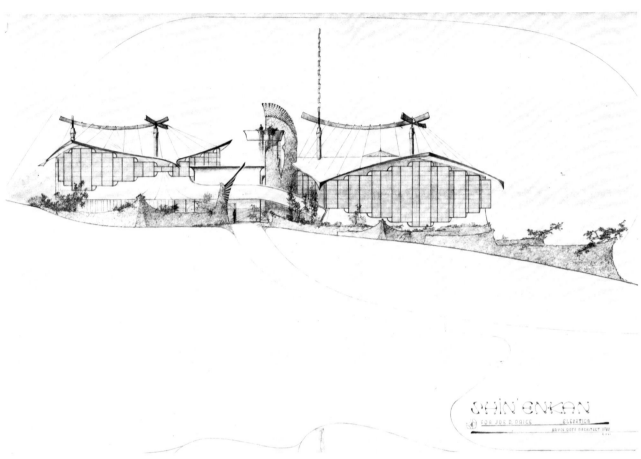

Elevation.

Shin'enKan

Architect
Bruce Goff

Client
Joe Price

Date of Commission
Spring 1978

Expected Date of Completion
Spring 1985

*Program and Nature of the
Collection*
New museum project, divided into two sections. The section for public exhibition is a multilevel gallery in a two-story space, with water gardens which provide naturally for the desired degree of humidity. Each of the inner gallery walls takes the place of a *tokonoma* (the traditional Japanese alcove used to display works of art), which is separated from the viewing platforms by the space over the water gardens. Thus no protective glass over the paintings is required. In this public section, the display will be changed 12 times a year; then each painting will return to the other section for the remaining 11 months. The other section has open storage so that the scholar and the collector, who know the paintings best, will be able to see them close up and study them. There is also a library and seminar study room in this section.

The collection, consisting chiefly of Japanese hanging scroll paintings and screens of the Edo period (1615–1867), is one of the finest and most extensive of its kind in the world.

Site and Context
To be determined according to the best place for the art; probably the West Coast.

Donor's Statement
Four hundred years ago in the tiny nation of Japan, an art form emerged which became virtually an island in the art world. This art arose when the great leaders of the warrior clans, who had unified the fragmented country, rejected as too somber and intellectual the symbolistic art of foreign neighbors which had been preferred by the previous rulers. They began to demand paintings which were purely decorative, made for no other purpose than to delight the eye, and often painted on a gold ground to lighten the interiors of the somewhat gloomy castles.

These new leaders built a capital where Tokyo now stands and called it Edo. Believing that society could be kept from changing, they closed the ports of Japan to the outside world. In this seclusion, Japan was able to recover from its devastating civil wars, and it began a 250-year period of unprecedented peace and internal development known as the Edo period.

The artist, suddenly freed from the dictates of outside influences, reached back to a time prior to these influences and resumed an art totally peculiar to himself. He copied no style, no technique from the outside world, for that world barely existed for him. From this cocoon-like isolation there emerged an art form unique in both content and style. It was also unique in its display. Only one painting was ever shown at one time; placed in a *tokonoma*, it was the only decoration in the room, viewed via soft, low light entering through the Shoji walls. The artist, knowing his painting would never have to compete with other objects, could make it as delicate and light as his skills would allow. He could omit all that was not essential.

It is impossible to build a true traditional museum for the display of Edo period paintings, for that would contradict the very reasons that the

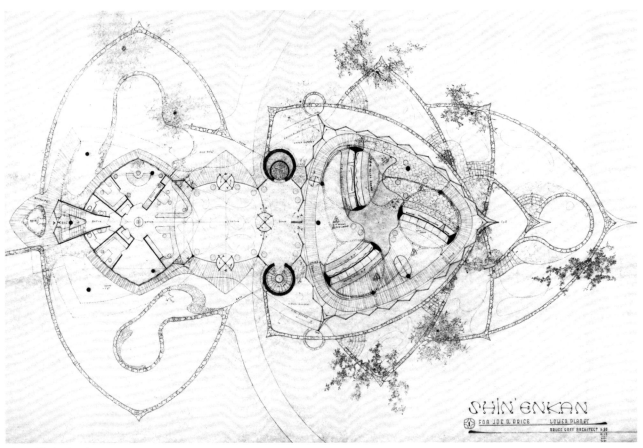

Plan of lower level.

art was created. The concept of a museum was not even imagined during the Edo period, so there is nothing on which to base a modern idea. It would be easy to take the Western concept of museum, and simply substitute the art of Edo for the heavily framed masterpieces encountered in our conventional galleries. But the art would suffer and the viewer would never have the opportunity to see that art as the artist who painted it intended it to be seen.

Therefore any museum to contain a large number of Edo paintings, intending to make the art look as the artist and client intended, must be of entirely unique design and concept. There is no convention to rely on, and simply using known Japanese materials and shapes would be cosmetic and would repeat the mistakes previously committed.

We must start by considering the art itself as the client. What will make the *art* happy, making *it* appear in its most beautiful state? It must be able to stand alone from a distance and up close. The lighting must closely match the low, soft lighting of the Japanese house, and it is imperative that the painting be displayed without a covering of glass, as this would destroy its delicacy and its intricacy. Japanese art was never intended to be on display for long periods of time, so ease of rotating the art is mandatory. The need for relatively high humidity also complicates the design problem.

Shin'enKan, designed by Bruce Goff, has solved these problems. It will make the client happy.

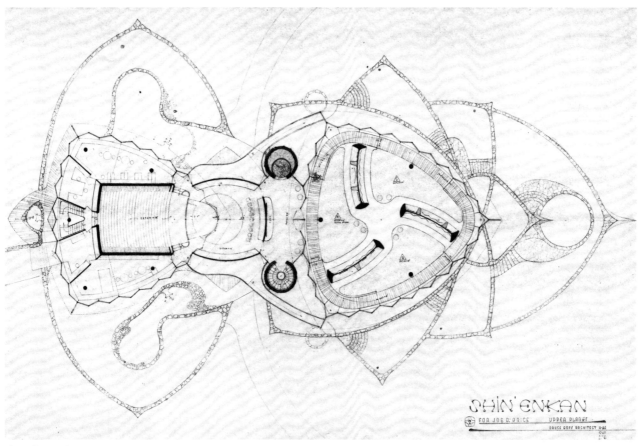

Plan of upper level.

Architect's Statement

One great contemporary architect has referred to the client as a mere "transient" and considers it foolish to plan the building around the client's special needs and desires. . . . This approach seems undemocratic and denies the right of the individual by forcing him into a discipline foreign to his nature. The client is entitled to a building which is Architecture, rather than some architect's abstract exercise.

There is never just one solution. The creative artist works intuitively and instinctively with the one he feels best with; it is a matter of choice from many possibilities.

We are blamed for "striving for effect," to which we plead guilty, because effects which are not striven for are not worth having. Certainly the effects of all the *great* architecture are earned and certainly architecture must have effect.
—*Bruce Goff**

* Bruce Goff's recent illness prevented him from drafting a special statement for this book. The Architect's Statement here has been adapted from some comments made in 1957, quoted in David G. De Long, "Bruce Goff and the Evolution of an Architectural Ideal," in *In Search of Modern Architecture: A Tribute to Henry-Russell Hitchcock*, ed. Helen Searing, to be published in the autumn of 1982 by the Architectural History Foundation/M.I.T. Press. I am grateful to Mr. De Long and the Architectural History Foundation for permission to reprint these quotations, which have previously appeared only in German.—H.S.

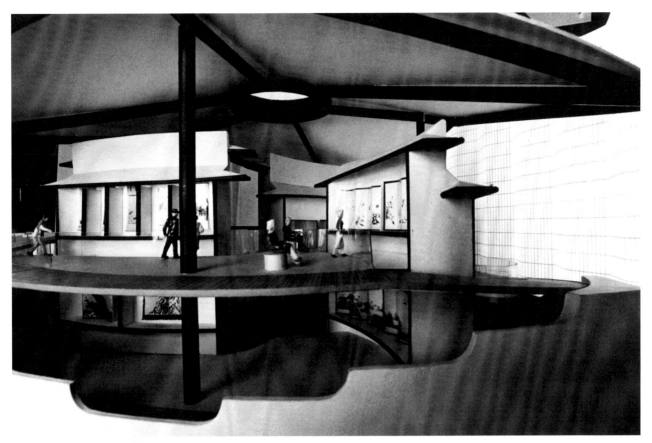

Model. Interior of upper galleries.

Historical Exemplars
The traditional Japanese house

Structure and Materials
To be finally determined depending on location; probably masts from which are strung steel cables which support the roof and which allow unobstructed viewing platforms; probably masonry for the foundation walls.

Lighting
Natural light via translucent Kalwalls, which simulate traditional Shoji screens (Japanese paper walls).

Some incandescent lighting as supplement.

Circulation
Elevator or stair to top level of the public galleries, then descent via a gently sloping ramp. Viewing platforms are separate from the ramp and are not on an incline.

Design
Bruce Goff

Model Maker
Bart Prince

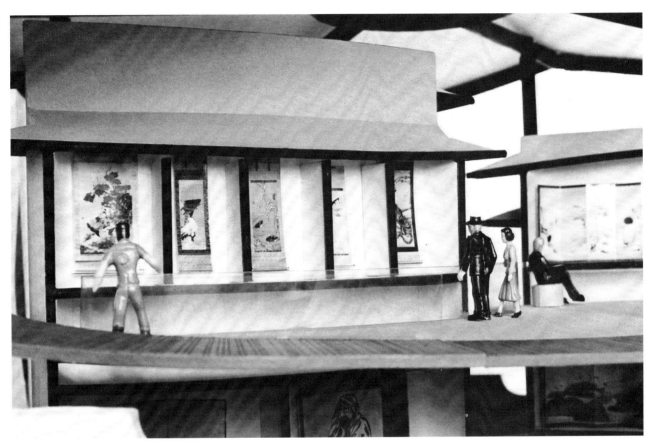

Model. Close-up of *tokonomas* (alcoves).

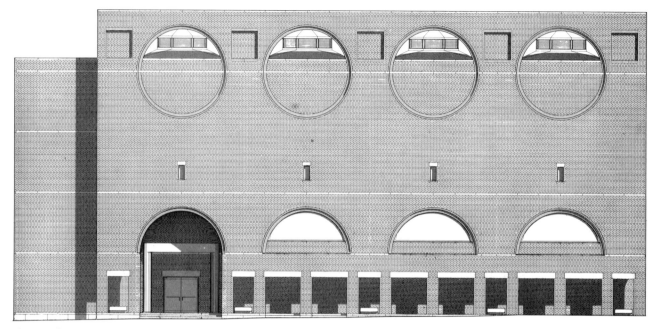

Elevation from Congress Square.

Portland Museum of Art
Portland, Maine

Charles Shipman Payson Building

Architects
I.M. Pei & Partners, Architects and Planners
Henry N. Cobb, Design Principal

Client
Portland Museum of Art

Date of Commission
November 1978

Expected Date of Completion
Fall 1982

Program and Nature of the Collection
Museum expansion project of 62,500 square feet. Of this, 20,000 square feet is for exhibition (and circulation), including 4,300 square feet for temporary exhibitions, 3,600 square feet for the Charles Shipman Payson Collection, and 4,100 square feet for the permanent collection. In addition, there is a 200-seat auditorium, a library, and a museum shop, as well as administrative, storage and work space.

The museum's holdings consist mainly of paintings, works on paper, sculpture, and decorative arts relating to Portland and to Maine, together called the State of Maine Collection. This includes the Payson Collection of four oils and 13 watercolors by Winslow Homer, the Hamilton Easter Field Foundation Collection of works by early twentieth-century artists associated with the Ogunquit art colony, and a growing collection of twentieth-century paintings, works on paper, and sculpture. In addition, there is a small group of European paintings.

Site and Context
Downtown Portland, fronting Congress Square. The site incorporates the McLellan-Sweat Mansion (1800, a house museum containing part of the decorative arts collection); the Charles Quincy Clapp House (1832, occupied by the museum-affiliated Portland School of Art); and the L.D.M. Sweat Memorial (1911, currently housing part of the collection).

Director's Statement

The project began in May 1976, when I first met with Mr. Charles Shipman Payson to discuss the future of his outstanding collection of paintings by Winslow Homer. Ultimately, his enthusiasm and commitment led to a new building to house, besides his gift of paintings, a new idea. Mr. Payson contributed significantly to the construction and endowment of the new facility. Additional support came from the Department of Housing and Urban Development and from individuals, corporations, and foundations with local, regional, and national affiliations. An Architect Selection Committee of nine members, including Mr. Payson, interviewed after preliminary screening three firms and selected Mr. Cobb because of his sensitivity to the city, the program, and the site, and the demonstrated record of museum construction of his firm.

The major design criteria were the opposite of what might be called theatre, impermanence, and the anonymous. Rather, our goal was to create beautifully proportioned spaces, incorporating natural light when appropriate, which would define an experience unique to the institution, and would provide the greatest and most pleasurable individual perception of the objects on view. We sought the timeless and best expression of elements from buildings which served as important specific, as well as general, precedents [see *Historical Exemplars*]. The dialogue during the concept phase was rich, exhausting, and comprehensive. The resulting scheme proposed a variety of internal spaces organized externally by deference to the existing buildings,

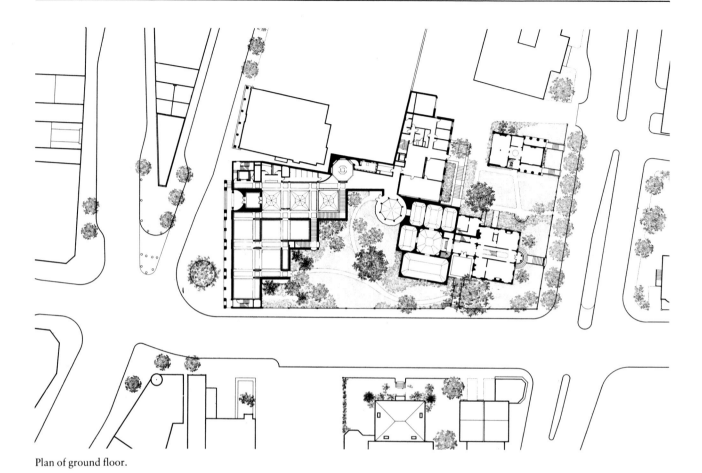

Plan of ground floor.

the challenge of the site, and the vernacular architecture of the city. The resulting building solves the problem while affirming Portland's sense of place.
—*John Holverson*

Architect's Statement

Portland, Maine, is a once-prosperous New England seaport which still retains much of the charm of a nineteenth-century town. The new museum building fronts on one of Portland's major public squares and is literally surrounded by landmark structures. Three of these, which are on the site and house collections and activities of the museum, will be preserved and integrated into the new museum complex. Thus one of the distinguishing features of the design problem has been the need to provide the extensive new facilities

in a form that will respect and render eloquent the living presence of history on a constricted and awkwardly shaped urban site. Our solution prescribes a stepped building form which, while fronting boldly on the square, grants primacy to its smaller neighbors within the museum precinct, and is shaped in plan so as to create outdoor spaces that provide a sympathetic landscape setting for the entire ensemble.

The exterior of the building is constructed of indigenous materials commonly found in the vernacular architecture of Portland. Our pur-

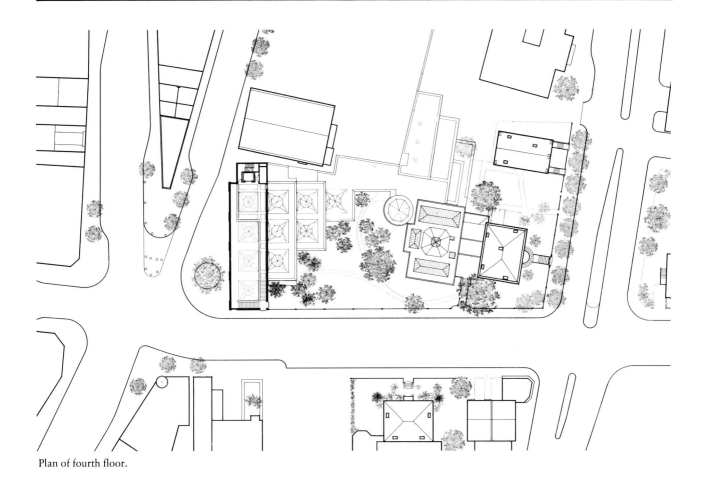

Plan of fourth floor.

pose in employing them is to extend and reanimate a traditon of masonry building which has significantly shaped the distinctive personality of this city. In the Congress Square façade, we have thought it appropriate to assert strongly the identity of the museum as a major institution, and have graded the scale and iconographic character of the compositional elements in ascending order from ground to roof. The street-level arcade is intimate and repetitive, with a single exception made for the entry arch, which penetrates to the second floor as one of a series of

large, semicircular openings. These in turn announce the major theme which is fully developed at the top of the wall, where an alternating rhythm of incised circles and squares refers to the spatial order of the building's interior. The projection of this wall above the roof allows it to engage the sky and assert its special role in defining and ornamenting Congress Square.

From the outset it has been our intention that the regional masterpieces which comprise the State of Maine Collection, beyond being made available to the public, should

be appropriately *celebrated* by the settings in which they are displayed. The diversity of the collection clearly suggests a variety of such settings: spaces from intimate to grand, and lighting from natural to artificially controlled. But there is equally a need for coherence in the totality of the museum experience and a comprehensible order in the arrangement of its parts. To achieve these goals, the new galleries are composed of a multilevel aggregation of identical spatial units, in dimension 20 by 20 by 11.5 feet, which are variously combined, vertically as well as horizontally, to

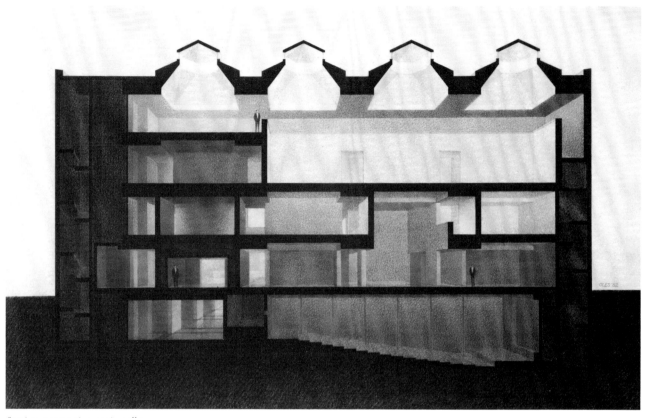

Section perspective, main gallery.

form larger spaces of diverse config-
uration within the unifying order of
the structural frame. Interstitial
spaces between each gallery unit are
20 by 6 by 10 feet; thus the circula-
tion spaces (rectangular) are dif-
ferentiated from the galleries
(square), which are places of con-
templation and repose.

From the moment of entry into the
Great Hall, the visitor will encoun-
ter a rich but disciplined elaboration
of interior space accompanying and
supporting the exhibition of works
of art. The domed clerestories, em-
ployed to capture the special quality

of "Portland light," will provide
controlled daylight entering from
above which suffuses, shapes, and
animates the space as it illuminates
the works of art within. Here the
fundamental elements of architec-
ture—space and light—are placed
simply and directly in the service of
the museum experience.
—*Henry N. Cobb*

Historical Exemplars
Dulwich College Picture Gallery,
London (Fig. 11); Palazzo Ducale,
Venice; The Frick Collection, New
York (1913–14, 1930); Kimbell Art
Museum, Fort Worth (1967–72);
nineteenth-century masonry build-
ings, Portland.

Structure and Materials
Structural frame of reinforced con-
crete columns and waffle-slab con-
crete floor plates. Exterior walls:
water-struck red brick with gray
granite trim (string courses, lintels,
sills, copings). Exterior and interior
granite paving with inset panels of

Section perspective, Great Hall.

pine boards in the exhibition galleries. Interior walls and ceilings of painted gypsum wallboard with plywood backup where required for exhibition use. Interior trim: painted wood for door frames, windowsills, handrails.

Lighting of Exhibition Spaces
Natural light via domed, louvred clerestories, supplemented by adjustable spot lighting on tracks.

Construction Cost
$8.2 million

Architects
I.M. Pei & Partners, Architects and Planners
Henry N. Cobb, Design Principal

Project Team: Leonard Jacobson, A. Preston Moore, Douglas Gardner, Geraldine Pontius, F. Thomas Schmitt, Senen Vina de Leon, Andrew West, Michael Goldsmith, Hans-Peter de Sepibus, Mirana Doneva

Landscape Architects
Hanna/Olin Environmental Design and Planning
Laurie D. Olin, Design Principal

Consulting Architects
Terrien Architects

Structural Consultants
Skilling, Helle, Christiansen, Robertson

Mechanical Consultants
Kunstadt Associates

Lighting Consultants
Jules Fisher and Paul Marantz, Inc.

Acoustical Consultants
Cerami and Associates, Inc.

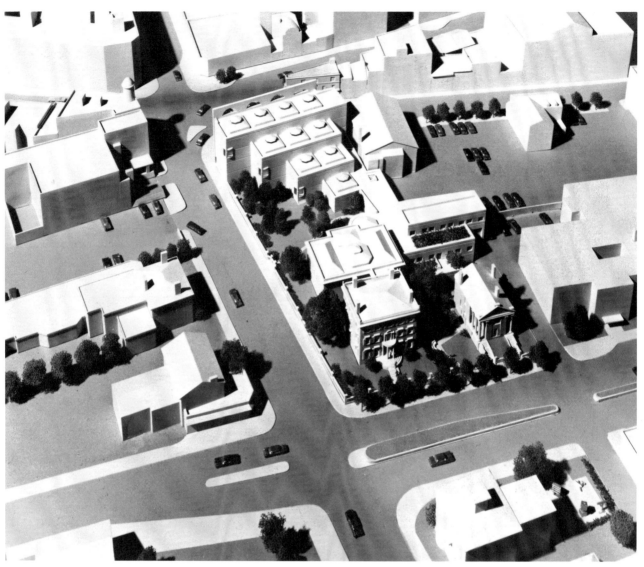

Model. View from Spring Street.

Life Safety Consultants
Rolf Jensen and Associates, Inc.

Security Consultants
Joseph M. Chapman, Inc.

Perspectivist
Paul Stevenson Oles

Model Maker
I.M. Pei & Partners Model Shop
George Gabriel, Director

General Contractor
Pizzagalli Construction Company

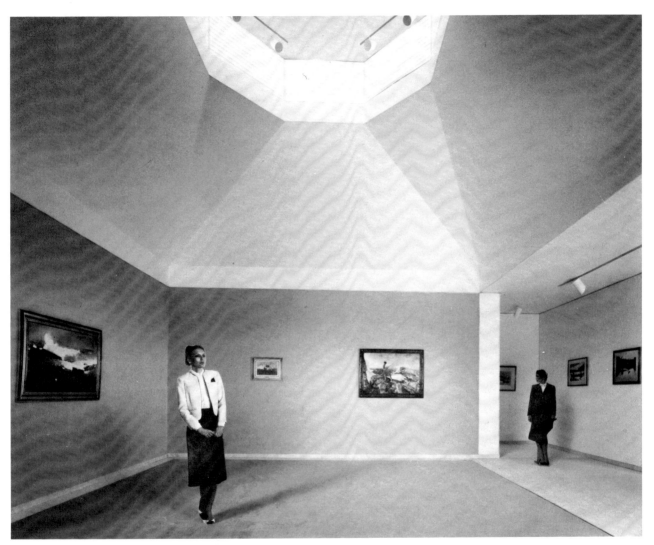

Model. Interior of gallery.

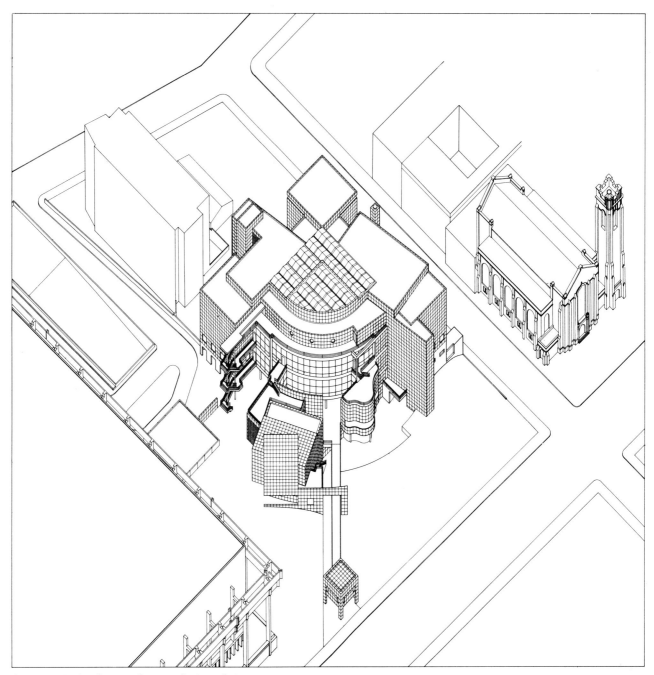

Axonometric view from southeast, preliminary design.

The High Museum of Art
Atlanta, Georgia

Architects
Richard Meier & Partners, Architects

Client
The High Museum of Art and the
Atlanta Arts Alliance

Date of Commission
August 1980

Expected Date of Completion
August 1983

*Program and Nature of the
Collection*
New museum of 130,000 square
feet. The 52,000 square feet of gal-
lery space for permanent collections
and temporary exhibitions is
organized on six levels so that the
museum can accommodate any size
loan exhibition. There is a 200-seat
auditorium, a museum shop, a café,
administrative, storage, and work
spaces, educational workshops,
classrooms, and support facilities.

The collection, multifarious and
growing, ranges from Early Amer-
ican and French decorative arts to
contemporary painting and sculp-
ture. It contains fine works from
many periods, including the Renais-
sance, Baroque, and Rococo. The
core of the collection is American
paintings, especially those of
Copley, Peale, Inness, Sargent,

Hartley, and Marin. There are im-
portant holdings of prints, photo-
graphs, American furniture, silver
and glass, French and Oriental ce-
ramics, and African art. It is the
largest publicly owned collection in
the Southeast.

Site and Context
The corner of Peachtree and Six-
teenth Streets, about two miles from
downtown. The new building is ad-
jacent to the Atlanta Memorial Arts
Center, the current focus of the
city's cultural activity. Peachtree
Street is the major thoroughfare and
has spatial as well as historical sig-
nificance. A new MARTA rapid-
transit station and the Colony
Square commercial complex are
both within a block and generate
substantial pedestrian traffic around
and through the site.

Director's Statement
Atlanta has had a long, if somewhat
insular, preoccupation with archi-
tecture. The presence of Georgia
Tech's School of Architecture since
1908 has created a large and am-
bitious community of articulate ar-
chitects with a keen awareness of
the city's ambience. Major building

projects are scrutinized with critical
interest by the press, the city's lead-
ership, and the architects them-
selves, and so it has been with the
new High Museum.

The shortcomings of the old mu-
seum's inconvenient and laby-
rinthine facilities, measuring only
45,000 square feet, overshadowed
the positive qualities of the institu-
tion. A new building had to be
thought out in terms of its function
as both an effective repository of art
and an agreeable public space. Pro-
jections had indicated the need for
more than 200,000 square feet in
the twenty-first century; as a result,
a plan evolved for 130,000 square
feet to be completed in 1983, with
provision for future expansions.

We wanted a highly functional de-
sign which would take into account
the realities of inflation and energy
control, as well as our coexistence
with the art school and the perform-
ing arts groups within our umbrella
organization, the Atlanta Arts Al-
liance. We hoped for a building
which would stand out by its design
and craftsmanship, draw attention
to itself, and beckon the visitor in-
side to enjoy the displays and ac-
tivities. The visitor should be

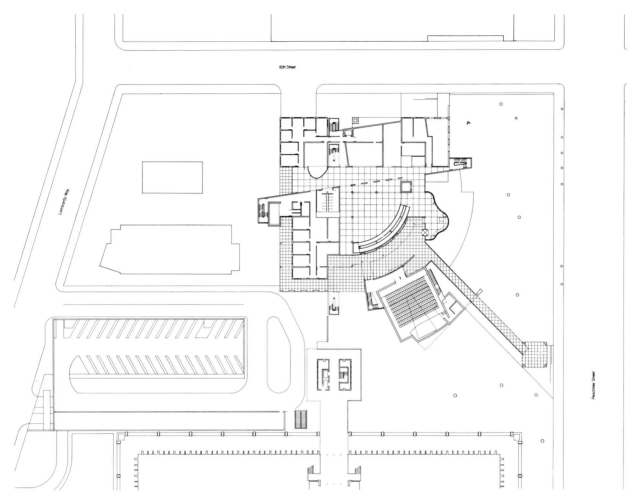

Plan of lower level, preliminary design.

altogether comfortable and able to enjoy the works of art in a calm, harmonious environment for easy viewing and logical progression. It seemed important to give a clear sense of orientation to the various aspects of the interior, as well as to the outside, with its marvelous trees, the adjacent Arts Center, and Peachtree Street, the principal landmark. In short, we wanted an inviting, open museum, not a fortress.

A remarkable aspect has been the project's swift, unhampered progress—an indication of possible funding in February 1979, and within the month a feasibility study prepared by the Atlanta architectural firm of Heery and Heery. More abstract explorations were pursued by the board and staff and by late summer, the board divided itself into task forces with assignments to establish a philosophy for the institution, identify its physical needs and the method of selecting the architect, and develop ways of raising the necessary funds. This deliberative process, which included many visits to other museums, continued until the end of the year.

In December 1979, Robert W. Woodruff, Atlanta's legendary "anonymous donor," announced his challenge grant of $7.5 million, and in January 1980, the board authorized the project. By June, Richard Meier & Partners had been chosen to design the building; by October, the Beers Construction Company of Atlanta had been selected as contractor.

That summer the museum began fund-raising in earnest and by fall all the board members had pledged a total exceeding $5 million. The public campaign began its arduous course in February 1981, and by

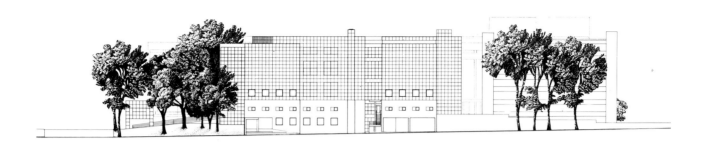

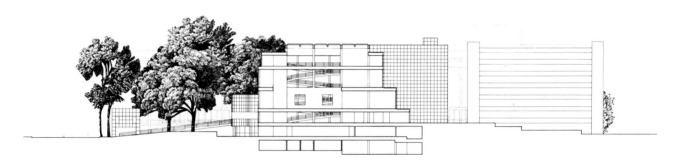

North elevation and section through north galleries looking south, preliminary design.

fall—a year in advance of expectations—the Woodruff challenge grant had been met. Donations have come from businesses, museum members, foundations, and private groups and individuals. More than nine-tenths came from the Atlanta community in some two thousand gifts, all private funds.

Meanwhile, Richard Meier lost no time in developing his plans from a detailed program prepared by the museum staff and the task forces. The architectural ideas grew organically from the museum's needs, its concept of itself and its aim to serve the public.

In July 1981, hundreds of Atlanta's children broke ground, shoveling sand and dirt out of the building site in an exuberant atmosphere of brass music and balloon launchings. Bulldozers stood at the ready that day, and by the end of the year foundations were being poured. When the building opens to the public in the fall of 1983, it will surely be a symbol of Atlanta's aspirations for a museum dedicated to quality and public enjoyment.
—*Gudmund Vigtel*

Architect's Statement

Most of the great European museums, which during the Age of Enlightenment came to have an educational as well as collecting role, are conversions from grand residences or palaces. The objects are seen in natural light in the environment for whose scale they were created. Today, the scale of the objects and of our expectations has changed, and natural light is considered harmful to the objects themselves. The High Museum of Art refers to the typological tradition of the Enlightenment and attempts to

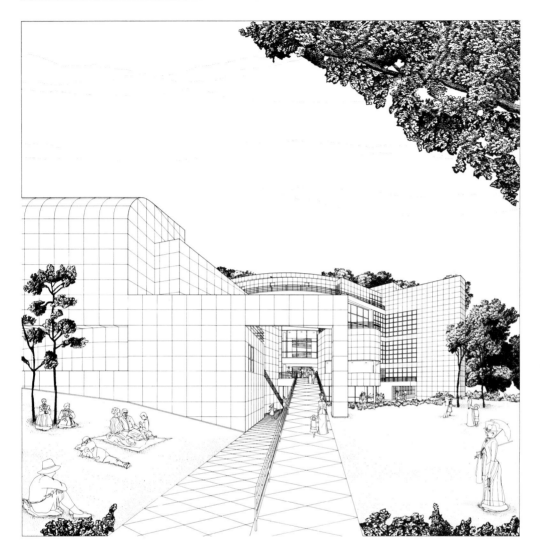

Perspective from entry pavilion, preliminary design.

resolve the best of the old and modern notions of the art museum. Our intent is to encourage discovery of aesthetic values and to convey a sense of the museum as a contemplative place. The circulation, lighting, installation, and spatial qualities of the design are intended to encourage people to experience the art of architecture as well as the art displayed.

The design of the High Museum developed as a series of architectonic responses to context in the broadest sense, understood to include not only functional, programmatic, and typological concerns, but also the physical, social, and historical context of the city. The importance of the site to Atlanta's future development, the pedestrian-oriented character of the neighborhood, the role of the museum as an urban and cultural symbol, and the self-consciously progressive tradition of the city of Atlanta all profoundly influenced the *parti*.

Because that corner of the site adjacent to the Memorial Arts Center facing Peachtree Street is especially beautiful, and because pedestrian traffic patterns so dictate, the entry is carved out of the building volume at this point. The priority of direction leads to a diagonal bisection of the square plan. Thus, in what would otherwise have been considered a classically balanced plan, we have introduced a crack through which the world rushes in. The interior ramp is the disrupting element which opens the plan, allowing an inwardly organized museum to be

Perspective, interior of
atrium, preliminary design.

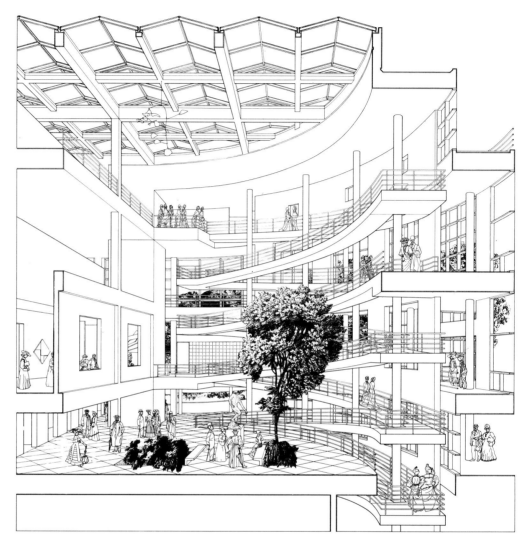

Perspective, interior of
atrium, preliminary design.

glimpsed by the casual passerby. The entry ramp reaches out to the city so that initiation into the realm of art begins at the street. It becomes a low, almost ceremonial promenade in preparation for the experience of viewing the art within. The auditorium is treated as a separate building for reasons of access and security; by its location in relation to the basic cubic volume of the main building, it reinforces the entry and forms part of the processional sequence.

In some ways the building can be seen as a commentary on the Guggenheim Museum. Circulation and gallery spaces enclose a central space, the beginning and the reference point of movement. The marvel of the Guggenheim is that the vertical movement provides a continual reference, not only to the central space filled with light, but to the art itself. The visitor is confronted with a multitude of ways of viewing the art. At the end of a particular exhibition, one can simultaneously see the beginning. The central problem

of the Guggenheim, however, is that the ramp as gallery induces a propelling motion inappropriate to contemplation. The sloping ceilings, floors, and walls are not only uncomfortable but render the display of paintings difficult. In Atlanta, we have attempted to reinterpret the particular virtues of the Guggenheim. By the manner in which we have separated vertical circulation and gallery space, we have been able to maintain the idea of the referent central space filled with light. In addition, galleries are

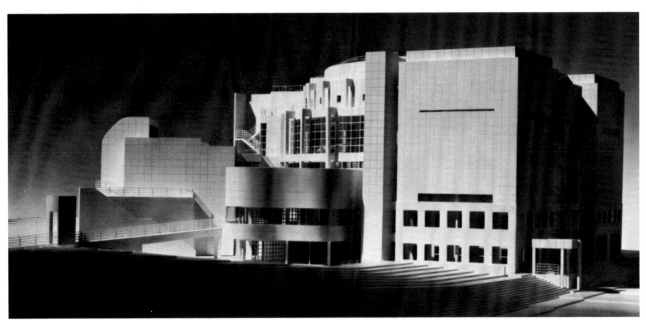

Model. Exterior from Peachtree and Sixteenth Streets, later stage in design.

organized to offer multiple vistas and cross-references, and to permit a museum experience that is at once intimate and historical. Exhibition spaces are so arranged that one can look across the atrium from one gallery to another; it is therefore possible to see a work of art within a gallery close up, or, coming around on the ramp, to see it again from a different perspective. Thus in addition to the changing perspectives of objects, visitors have a full panorama of internal circulation and views of the atrium and the outdoors. Because the atrium walls have interior windows, views of the city are framed. The interior scale relates to the collections, which include many small paintings, drawings, photographs, and objects, as well as large-scale works.

Apart from its purely functional role, light in this building is a constant preoccupation, a symbol of the museum's purpose. Light is basic to the architectural conception: the museum is meant to be both phys-

ically and metaphysically "radiant." The building is intended both to contain and to reflect light, and in this way to express the museum's purpose as a place of enlightenment and the center of the city's cultural life.
—*Richard Meier*

Structure and Materials
Structural frame and slabs of reinforced concrete. On the exterior, a granite base, which encloses the support facilities, forms a datum for the porcelain-enameled steel panels above. Interior wall and ceiling surfaces: painted gypsum wallboard with a plywood backup in exhibition areas. Flooring: granite on the main level, wood on the upper floors.

Lighting
A large skylight over the atrium and seven pyramidal skylights over the upper-level exhibition area bring controlled natural light into the movement spaces. Daylight enters

the galleries from the atrium and a few exterior windows. The general and specific levels of illumination in exhibition areas are maintained by artificial means—a combination of recessed and track spot fixtures.

Circulation
The semicircular interior ramp connects all levels and permits large numbers of visitors to circulate.

Historical Exemplars
The Glyptothek (Figs. 4–6) and Alte Pinakothek in Munich by Leo von Klenze; the Altes Museum (Figs. 7–10) in Berlin by Karl Friedrich Schinkel; the Frick Collection in New York (1913–14, 1930); the Solomon R. Guggenheim Museum, New York (Figs. 46–48).

Construction Cost
$15 million

Architects
Richard Meier & Partners, Architects—Richard Meier, F.A.I.A., Gerald Gurland, A.I.A., principals-

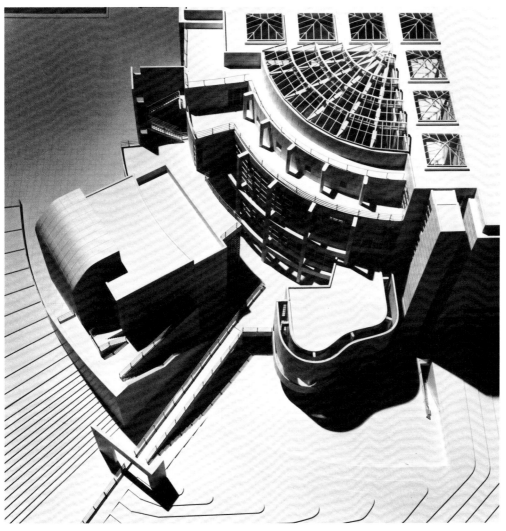

Model. View from Peachtree Street, later stage in design.

in-charge; Philip Babb, Michael Palladino, associates-in-charge; Stanley Allen, Susan Berman, Andrew Buchsbaum, David Diamond, Steven Forman, George Kewin, Dirk Kramer, Richard Morris, Vincent Polsinelli, Patricia Sapinsley, Greta Weil.

Model Maker
Albert Maloof

General Contractor
Beers Construction Company

Structural Engineers
Severud-Perrone-Szegezdy-Sturm

Mechanical and Electrical Engineers
John Altieri, P.E.

Lighting Consultants
George Sexton Associates

Landscape Architects
The Office of P. DeBellis

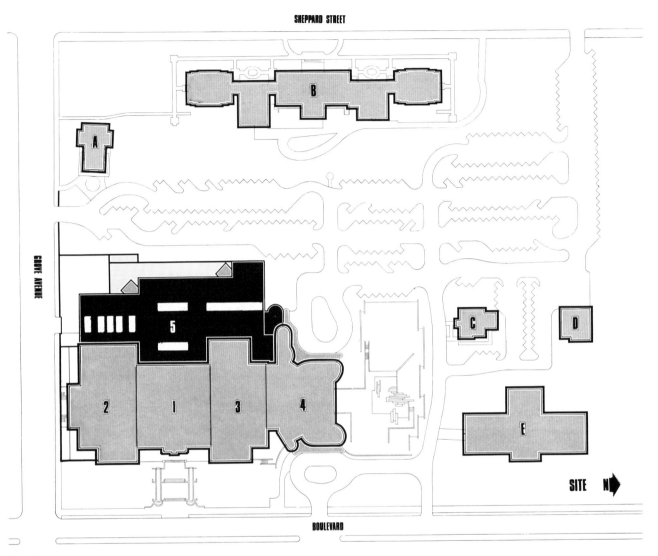

Site plan.

Key

1. Original Museum 1936
2. South Wing 1970
3. Theatre Wing 1954
4. North Wing 1976
5. Proposed West Wing

A. Confederate Memorial Chapel
B. Home for Confederate Women
C. Robinson House
D. Shop
E. United Daughters of the Confederacy

Virginia Museum of Fine Arts
Richmond, Virginia
West Wing

Architects
Hardy Holzman Pfeiffer Associates

Client
Virginia Museum of Fine Arts

Date of Commission
September 1980

Expected Date of Completion
Fall 1984

Program and Nature of the Collection
Museum expansion project of 90,000 square feet: 45,000 square feet for exhibition and a Main Hall; 2,500 for a new theatre entrance; 14,500 for storage of the Lewis Collection; 13,500 for loading and garage; and 14,500 for mechanical services. 20,000 square feet in the existing building is being remodeled also.

The West Wing will house two new permanent collections: French, English, and American paintings, small sculptures, and works on paper (the planned gift of Mr. and Mrs. Paul Mellon); and Art Nouveau, Art Deco, and contemporary American objects (the planned gift of Sydney and Frances Lewis). The museum's holdings span history and include objects of various sizes and media from the Far East, Europe, and the Americas, from ancient, medieval and modern periods. The Lillian Thomas Pratt Collection of Russian Imperial Jewels is the largest public collection of Fabergé objects outside the U.S.S.R.

Site and Context
Robert E. Lee Confederate Memorial Park on the Boulevard, a major residential avenue. Other public buildings share the site. The West Wing addition faces the Home for Confederate Women, a long, two-story stone structure with Italianate features, and the Confederate Memorial Chapel and Robinson House, small-scale domestic buildings.

President's Statement
The first state-owned art museum in the United States, the Virginia Museum was built to provide a public home for an important art collection donated to the state by Judge John Barton Payne in 1919. The central core, a mere third the size of the present building, was constructed as a W.P.A. project and opened in 1936. Funding was the result of a gift of $100,000 from Judge Payne, on the condition the state appropri-ate an amount equal to, or if necessary greater than, his gift to complete construction. This marked the beginning of a tradition of joint support by both the private and public sectors, for although the operating funds are appropriated annually by the legislature, all the art acquisitions are the result of gifts, bequests, or purchasing funds from private sources.

With ever-increasing public use of the museum, three additions, totaling 225,000 square feet, were necessary. In 1954, a grant from the Old Dominion Foundation and a legislative appropriation made possible the construction of the Theatre Wing, with its 500-seat facility. The South Wing, completed in 1970, provided more gallery space, offices, storage areas and an enlarged art reference library. The North Wing, with galleries, a 375-seat auditorium/lecture hall, theatre work space, members' suite and restaurant, public cafeteria, and spacious sculpture garden, was completed in 1976. The North and South Wings were funded by state appropriations alone.

It is now once more necessary to augment the museum's gallery areas. The West Wing, the fourth

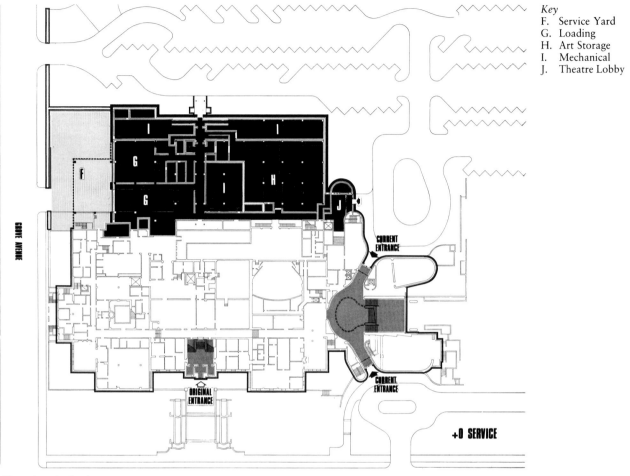

Plan of service level.

major addition, will more than double the exhibition space. Again, funding is being drawn from public and private sources. Through this continuing partnership of support, the museum strives to fulfill its legislative mandate: to provide education in the arts for all Virginians.
—*Charles L. Reed, Jr.*

Architect's Statement

The West Wing of the Virginia Museum of Fine Arts is the fourth addition to the original building of 1936, constructed in the style of a Georgian mansion. It enclosed 50,000 square feet of museum activities in a grand domestic setting, with a central hall and entry stair allowing access to symmetrical upper galleries and a lower service level. The exterior, consisting of a limestone base, cornice, and projecting pedimented pavilion, with a narrow brick midband and limestone-enframed windows, was detailed to provide a lively composition of shadows and highlights in the Virginia sun. The 1954 and 1970 additions were composed as end pavilions and differed from the original design only in detailing and materials—the façades are less three-dimensional and are predominantly of brick, with limestone used only as an accent. The North Wing, completed in 1976, broke with its predecessors by arranging four finger-like elements around a large exterior plaza and is constructed of smooth, curving brick walls which rise from grade to a limestone band at the coping.

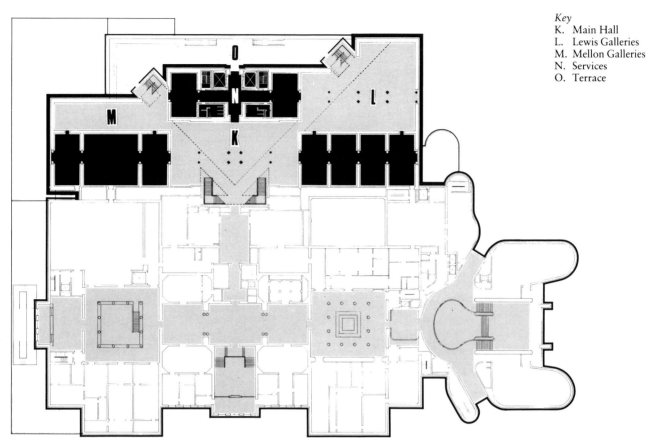

Plan of gallery level.

A significant difference between the West Wing and its predecessors lies in its location. It occupies space formerly used as a service yard and has no orientation to the Boulevard, but will face three of the other buildings in the park. Since the north and south additions did not follow the details or location of materials of the original building, a strict continuation of these to the west was not possible. Rather than developing a new set of design parameters, however, the new addition returns to the general compositional principles of the 1936 building.

The mass of the West Wing is divided into three major elements, not dissimilar to the Georgian portion of the Boulevard façade, and is placed on a large, continuous base. The base is part of the main body of the wing at the north end. In the central section it forms the edge of the terrace and to the south it encloses the service yard. On the terrace at the juncture of the elements are two glass-enclosed stairs. In addition to providing open access between gallery levels, they complement the pedimented pavilions of the original building. The primary exterior surfacing material

will be limestone. Four different finishes will simulate the shades and shadows of the 1936 building. Near the top of the façade, two polished granite bands enclose one roughback band to match the varying cornice heights of the existing structures. The central portion of the façade will have a reversal of patterns to accentuate this section of the composition and announce the entrance to the terrace and park.

The West Wing, designed as a single unit to house the two different collections, will almost double the available exhibition space. Perma-

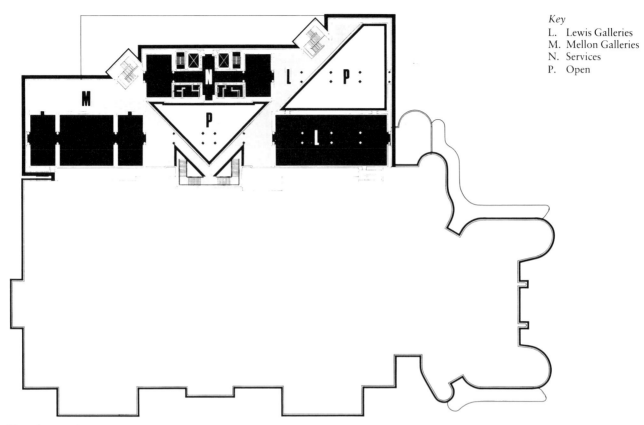

Plan of mezzanine.

nently installed in the ten Mellon Galleries will be small-scale objects (only one item is expected to be larger than 30 by 24 inches) from the late nineteenth and early twentieth centuries. The eight Lewis Galleries, except for the decorative arts, will accommodate changing displays of contemporary objects. Only 30 percent of the total items in the collection will be presented at one time.

An exposed concrete structure and the axial relationship of new circulation to existing routes provide a framework which visually ties all the galleries together.

The Mellon Galleries will appear smaller than the structural volume. A raised fabric-covered wall surface topped by a continuous three-foot-radius cove has been inserted within the structural frame. The Lewis Galleries accentuate the volume of each space to better accommodate the large-scale contemporary works. Painted walls run from floor to ceiling in five of the rectangular gallery spaces. The one large gallery, 75 by 60 by 30 feet, is flexible except for its perimeter walls. Three 15-by-18-foot movable partitions will be located in the gallery (at all times) in addition to a number of smaller, 9-foot 6-inch square partitions (which can be removed). These elements can be used individually or as small grouped units placed in a variety of configurations.
—*Hardy Holzman Pfeiffer Associates*

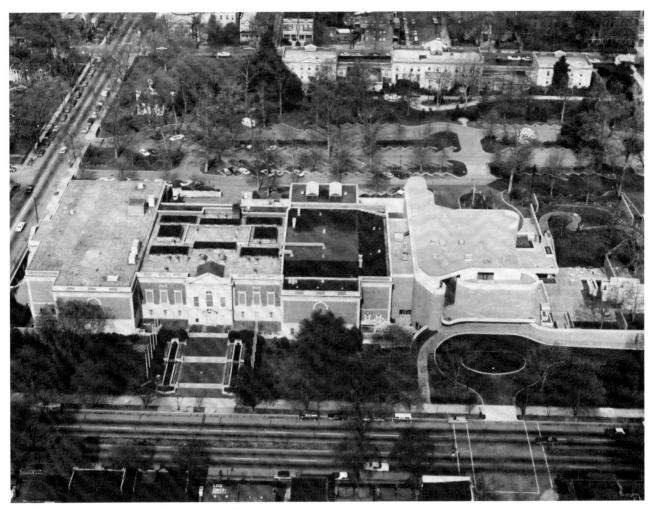

Aerial view, showing original building and later additions.

Structure and Materials
Reinforced concrete structure. Exterior wall surfaces: Indiana limestone in four finishes, trimmed with polished granite. Interior floors: hardwood and carpeted. Interior walls: painted or fabric covered.

Lighting
During the last 25 years conservators have developed guidelines for the lighting levels, control of ultraviolet light, and the display of sensitive materials in gallery settings. If these guidelines were the only criteria most gallery spaces would have exclusively artificial light. However, during this same period, studies have also shown that changeability of natural light best reveals the true colors of painted objects. The West Wing will have four types of lighting: artificial light for a number of galleries including one for works on paper; skylights in the French Impressionist and Post-Impressionist galleries to provide the most favorable colored light for these objects; clerestory/skylights to illuminate 30-foot-high architectural spaces; windows to orient the visitor to the outside.

Circulation
The Mellon and Lewis Galleries are linked by a Main Hall entered from the existing building, on axis with the original front entrance and Tapestry Hall. This two-level Main Hall is the departure point to both collections; at its midpoint a double columned axis runs the length of the smaller galleries at both levels, and at the far end is a portal to a shared exterior terrace.

Mechanical Environment
Only a small variation in temperature and humidity can be tolerated

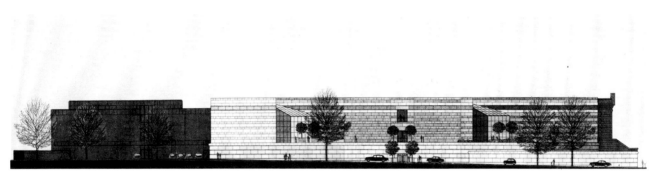

West Wing, west elevation.

in museum spaces. Every effort has been made to reduce the unending demand for energy consumption. All skylights are double glazed, fitted with mechanically adjustable louvres, and have translucent bottom laylights. Glass terrace pavilions are designed to exclude 86 percent of the natural light. Mechanical systems have free-cooling cycles, heat exchangers, and potential for future solar supplement and heat-recovery systems.

Architects
Hardy Holzman Pfeiffer Associates; Hugh Hardy, Malcolm Holzman,

Norman Pfeiffer, Curtis Bales, Al Delaney, James DeSpirito, Neil Dixon, David Gross, John Harris, Pam Loeffelman, David Stein

Structural Consultants
LeMessurier Associates/SCI

Mechanical Consultants
Joseph R. Loring and Associates

Lighting Consultants
Jules Fisher and Paul Marantz, Inc.

Acoustical Consultants
Jaffe Acoustics, Inc.

Security Systems
Joseph M. Chapman, Inc.

Landscape
Villa/Sherr Associates

Kitchen Consultants
Laschober and Sovich, Inc.

Architect's renderings of a proposed South Wing, undated (1940s?). Above: elevation from Grove Avenue; below: elevation from the Boulevard, with original building in center.

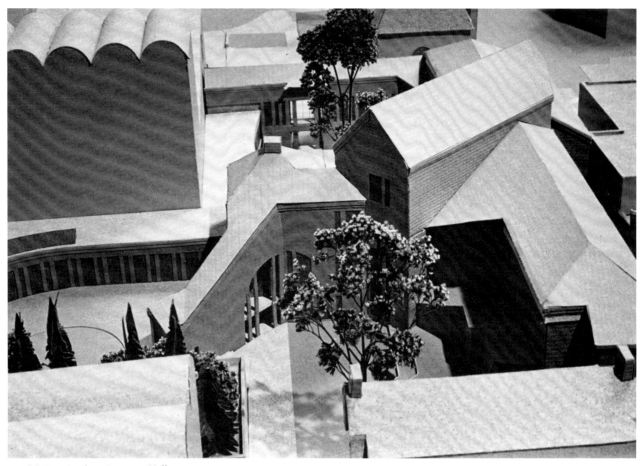

Model. Exterior from Brewster Hall.

Hood Museum of Art
Dartmouth College, Hanover, New Hampshire

Architects
Charles W. Moore, Moore Grover Harper, P.C.

Client
Dartmouth College

Date of Commission
May 1981

Expected Date of Completion
Fall 1983

Program and Nature of the Collection
Museum of 37,000 square feet connected to Hopkins Center and Wilson Hall, both given over to the performing arts. There is 11,700 square feet of gallery space for permanent, changing, and alumni exhibitions, a 244-seat auditorium, plus offices, work space and two classrooms. General storage and mechanical areas are in the two subterranean levels, and galleries and professional offices in the two above-ground levels. Possibility of expansion exists by continuing the horizontal format south or east.

The collection ranges from Egyptian and Assyrian to contemporary art, but focuses on European and American paintings, prints, and drawings of the nineteenth and twentieth centuries, and on African, pre-Columbian, and American Indian art. The museum has approximately 10 major and 20 smaller shows per year that draw from the permanent collection, from loans, from regional artists and the college's Artist-in-Residence program.

Site and Context
The site is surrounded by college buildings on four sides, with one corner fronting the traditional New England green that forms the center of the college and the town. To the west is Hopkins Center, to the north Wilson Hall, a Richardsonian building of brick and stone which will contain Hopkins Center offices and teaching spaces. To the east is the heating plant, to the south a small dormitory.

Director's Statement
Dartmouth College has planned a museum of fine arts since the late 1950s, when Hopkins Center for the Performing Arts was built to the designs of Wallace Harrison. Because of budgetary pressures at that time, it was necessary to compress the spaces planned for gallery functions. In 1978, however, a substantial gift to be used for construction of a museum was provided by Harvey Hood, a devoted trustee and an alumnus of the class of 1918.

Other friends and alumni made major gifts and a building committee was formed to consider, interview, and recommend an architect. It was felt that it was vitally important to obtain one conversant with a collegiate setting and the special requirements that implies, one who would not be uncomfortable working with a great number of committees and with a constituency that includes, but is not limited to, students, faculty, administrators, alumni, donors, and residents of the region. Design criteria centered on a building that would clearly speak to its own era, announcing itself as a structure of the last quarter of the twentieth century, while at the same time being in harmony with the nineteenth-century flavor of the Dartmouth campus.

There were no existing museums we found exemplary and looked to as models. This is by no means an indictment of previous museum architecture but a recognition that there are strengths and weaknesses associated with all the designs. Careful examination of other museums reinforced our initial belief that flexibility of operation was the key component in developing our program, for our collection is very

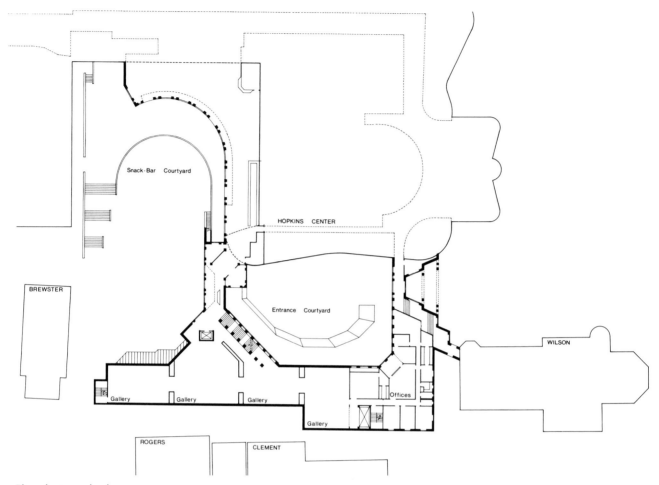

Plan of entrance level.

much one in process, which will grow and evolve over the next decades.

All these factors led to the selection of Charles Moore, who has a long personal acquaintance with academic life. A number of architects who had completed major museum projects were ruled out because of the perceived lack of willingness to allow the degree of client participation Dartmouth felt requisite. Although Moore had not then designed a museum that had been completed, he and his associates demonstrated an unusual willingness to develop a design in close consultation with the museum director and the other members of the Dartmouth community.
—*Richard Stuart Teitz*

Architect's Statement

In the 20 years since it was built, Hopkins Center at Dartmouth College has become a center for the arts, especially the performing arts, for much of upper New England. Its barrel-vaulted brick buildings are an exuberant recollection of the optimistic sixties. The visual arts, however, have occupied only corners of the Center. Now, with a gift from the Hood family of Boston, there is to be a museum of fine arts with a separate identity but with a close relationship to Hopkins Center. The choice of a site which would favor both the separate identity of the Hood Museum and the "osmosis" between Hood and Hopkins Center, and avoid an extensive network of mostly underground hazards, was the first business of the architects and a hard-working committee. We thought that efforts to quantify the competitive virtues of six possible sites could only be misleading and so proposed a kind of

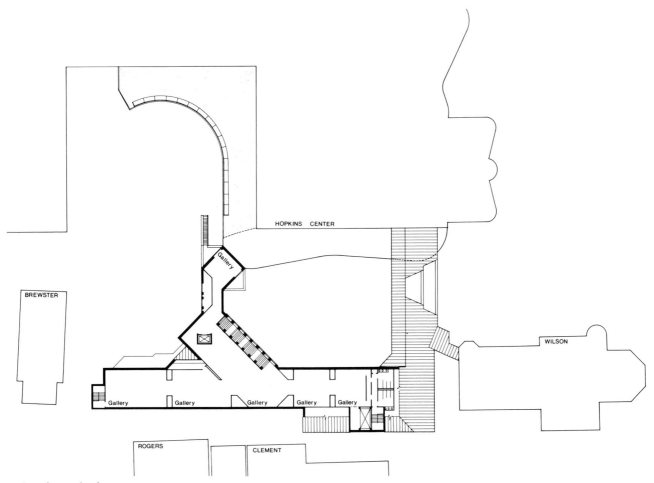

Plan of upper level.

beauty contest—we would design a building for each one of these six sites. From our temporary offices adjoining the snack bar at Hopkins, where we spent much of the summer and fall of 1981, we quickly made schemes for no fewer than 17 art museums, some entirely new buildings and some occupying Wilson Hall, a much-beloved Richardsonian building on the Hanover Green east of Hopkins Center.

The scheme that finally, and rather unexpectedly, came to have the group's backing only gradually emerged during the discussions. It sits mostly in the middle of the large block, neither on the Green nor on commercial Lebanon Street to the south, but close to the snack bar and the center of Hopkins Center. The museum's identity on the Green is established by a courtyard entered between Hopkins Center and Wilson, and a connection at the entrance to both the other buildings. (Wilson is being refurbished for the arts.) Its connection to the courtyard in the center of Hopkins is a strong one, and a rear court allows a place for Brewster Hall, a three-story dormitory which once had seemed annoyingly in the way.

There is passage through the entrance pavilion, with a separate entrance for an auditorium. Inside the museum, from the snack-bar level, there is entry to a series of galleries at the same level, and a grand stair with New Hampshire granite pylons to a lofty gallery above, which cuts across a long series of galleries axially arranged, a solution which owes a lot to the long galleries in English stately homes.

The building is of brick (like Hopkins Center) with some granite, a combination much favored in New Hampshire. Its idiom is meant

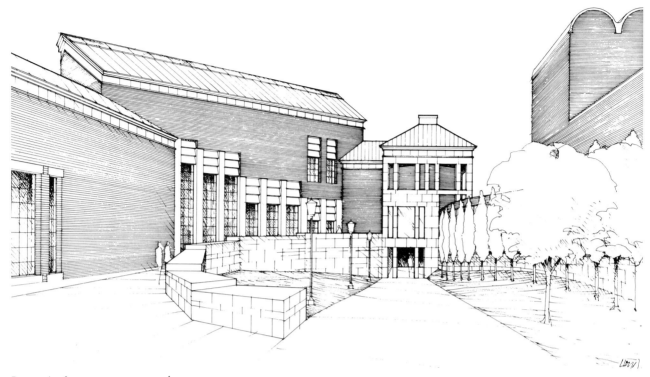

Perspective from entrance courtyard.

to make it an unobtrusive good neighbor to the much larger Hopkins Center and a reinforcement to the charms of Wilson Hall. Its courtyards are used to join with them and to hold works of art.
—*Charles W. Moore*

Historical Exemplars
Oxford and Cambridge courtyards.

Structure and Materials
Structural frame of reinforced concrete columns and one-way ribbed concrete floor slab, steel roof framing. Exterior walls: brick and granite veneer with granite and color-glazed brick trim. Floor surfaces: wood and carpet. Interior surfaces: walls and ceilings of painted gypsum wallboard with plywood backup where required for exhibition use. Interior trim: painted and natural wood.

Lighting of Exhibition Spaces
Natural light by skylight in some spaces, with artificial area and task lighting throughout.

Constuction Cost
$5.4 million

Architects
Moore Grover Harper, P.C.
Charles Moore, F.A.I.A.,
J.P. Chadwick Floyd, A.I.A., Glenn Arbonies, A.I.A., Robert L. Harper, A.I.A.

Project Architect
Richard Loring King, A.I.A.

Project Manager
James Cabell Childress, A.I.A.

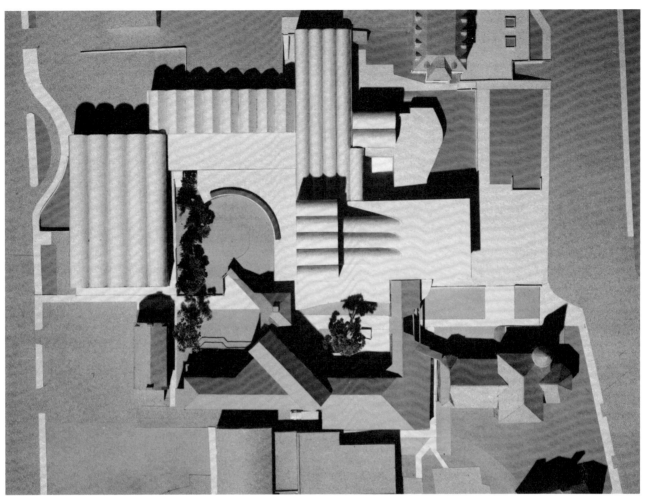

Model. Bird's-eye view of Hood Museum of Art and Hopkins Center, oriented toward plan.

Team Members
Julia Heminway Miner, James
Ralston Martin, Leonard J. Wyeth,
F. Bradford Drake, Beth Dana
Rubenstein

Model Maker
Moore Grover Harper

Contractor
Jackson Construction Inc.

Structural Engineers
Besier Gibble and Quirin

Mechanical Engineers
Helinski-Zimmerer, Inc.

Acoustical Consultants
Bolt, Beranek, Newman

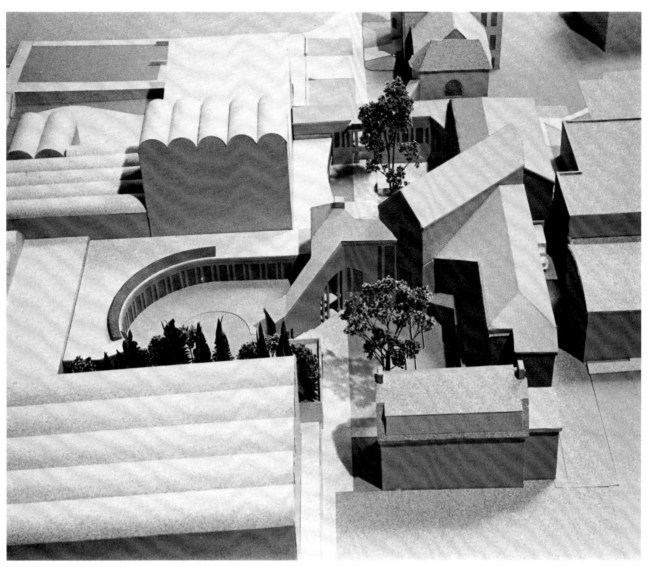

Model. Exterior: Hopkins Center and snack-bar courtyard (left), Brewster Hall (lower right).

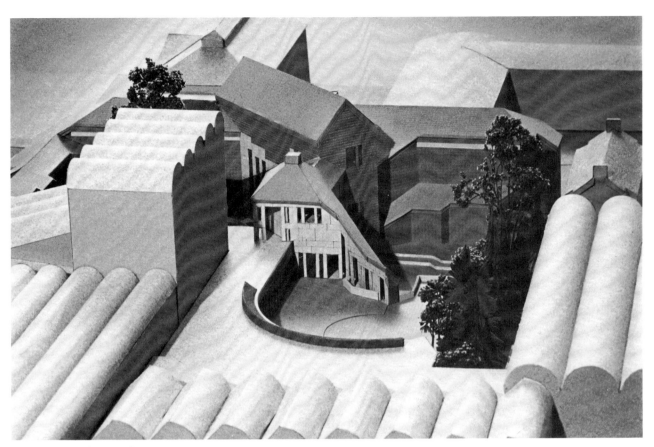

Model. Exterior from Hopkins Center.

Architects' Biographies

Edward Larrabee Barnes

Born in Chicago in 1915, Edward Larrabee Barnes, F.A.I.A., studied at Harvard University (B.S., 1938). After a year spent teaching English and Fine Arts at Milton Academy, he returned to Harvard to study architecture at the Graduate School of Design (M. Arch., 1942). There he worked with Walter Gropius and Marcel Breuer, and was awarded the Sheldon Traveling Fellowship. As a lieutenant in the U.S. Navy, he served as a naval architect from 1942 until 1947. The next year he established his private architectural practice in New York City and remained the sole principal of the firm until 1981, when he formed a partnership with two of his associates. Over the years, Barnes has also been an architectural critic and has taught at Pratt Institute, Harvard, Yale, and the University of Virginia, among others. The office has won numerous awards, among them Honor Awards and the Firm Award from the American Institute of Architects.

The firm's commissions have varied: major works include the Haystack School, Deer Isle, Maine (1962), IBM World Trade Headquarters, Mt. Pleasant, New York (1974), IBM Headquarters on Madison Avenue (1982), and 535 Madison Avenue (1982). Museum design has been a specialty of the firm, which counts among its work the Walker Art Center in Minneapolis (1971), the Sarah Scaife Gallery in Pittsburgh (1974), the Wichita Art Museum (1977) and the Asia Society in New York. Currently being designed is the Fort Lauderdale Museum of Art. Plans have been completed for the Santa Fe Indian Museum, and the Crocker Art Museum in Sacramento.

Henry Nichols Cobb

Henry Nichols Cobb, F.A.I.A., one of the three founding principals of I.M. Pei & Partners, was born in Boston in 1926. He attended Harvard University (B. Arch., 1946), and Harvard Graduate School of Design (M. Arch., 1949). From 1949 to 1950, he worked as an architect in the firm of Hugh Stubbins, and then worked in the Architectural Division of Webb and Knapp, Inc.

Throughout his career, Cobb has coupled his work as an architect with teaching. He has held the Davenport and Bishop visiting professorships at Yale University and is currently Studio Professor and Chairman of the Department of Architecture at the Harvard Graduate School of Design. In 1977, he received the Arnold W. Brunner Memorial Prize from the American Academy and Institute of Arts and Letters. He is a trustee of the American Academy in Rome.

Among the major works for which Cobb has been responsible as a design partner are the Place Ville Marie, Montreal (1962), the John Hancock Tower in Boston (1976), and One Dallas Centre (1979). Cobb has also played a major role in his firm's extensive projects in urban design and city planning, including urban renewal plans for Government Center, Boston (1961), and Bunker Hill, Los Angeles (1963). Recently, he has been responsible for downtown revitalization projects for Augusta, Georgia, and New Brunswick, New Jersey.

Bruce Alonzo Goff

Bruce Goff was born in Alton, Kansas, in 1904. At the age of 12 he was apprenticed to the firm of Rush, Endacott, and Rush in Tulsa, becoming a partner in 1928. In 1934

he moved to Chicago and worked briefly for the design firm of Alfonso Ianelli. In 1936 the Libby-Owens-Ford Glass Company asked him to head their Vitrolite design department in Toledo, Ohio. Goff lived there for a short time, returning to Chicago in 1937, where he taught at the Academy of Fine Arts. During World War II he served in the construction division of the U.S. Navy (the Seabees). Since then he has practiced in Berkeley, California, Bartlesville, Oklahoma, and Kansas City, Missouri; currently his office is in Tyler, Texas. From 1947 to 1955 he was Chairman of the School of Architecture at the University of Oklahoma in Norman.

Goff's first executed work, a summer house near Los Angeles for B.L. Graves, was designed in 1919. His Boston Avenue Methodist-Episcopal Church in Tulsa, of 1926–29, won him early recognition. He is especially known for his innovative use of unusual materials, such as coal, slag, suspension cables, cellophane, and feathers, and of structures, such as the Quonset hut he employed for the Seabee Chapel in Camp Parks, California, of 1945. He has designed buildings for a wide variety of functions but the vast

majority of his commissions are for single-family houses, among them, the Triaero House in Fern Creek, Kentucky (1941); the Ledbetter House (1947) and the Bavinger House (1950–55), both in Norman; and the Gryder House in Ocean Spring, Mississippi (1960). His only constructed gallery space to date is the addition to the Joe Price House in Bartlesville, Oklahoma (1968).

Hardy Holzman Pfeiffer Associates

Hardy Holzman Pfeiffer Associates was established in 1967 as successor to Hugh Hardy & Associates, formed in 1962. The principals are Hugh Hardy, F.A.I.A. (B. Arch., Princeton University, 1954, D'Amato Prizeman; M.F.A./M. Arch., Princeton University, 1965), Malcolm Holzman, F.A.I.A. (B. Arch., Pratt Institute, 1963), Norman Pfeiffer, F.A.I.A. (B. Arch., Cum Laude, University of Washington, 1964; M. Arch., Columbia University, 1965), and Victor Gong, R.A. (B. Arch., with Honors, University of California, Berkeley, 1969; M. Arch., University of Pennsylvania, 1971). Individual projects have merited numerous awards for

excellence in architecture and urban design, including American Institute of Architects Honor Awards in 1976, 1978, 1979, and 1981. In addition, HHPA has received recognition for its work as a whole: the 1974 Arnold W. Brunner Memorial Prize in Architecture, presented by the American Academy and Institute of Arts and Letters; the 1978 Medal of Honor from the New York Chapter of the American Institute of Architects; and the 1981 A.I.A. Architectural Firm Award.

Since its inception, the firm's work has been almost equally divided between new construction and preservation/adaptive use. While completed projects include institutional and commercial structures and housing, HHPA is particularly well known for design of facilities for the visual and performing arts. Among the firm's visual arts projects, renovations, and additions are: Simon's Rock Art Center in Great Barrington, Massachusetts (1966); MUSE in Brooklyn, New York (1968); the Cultural Ethnic Center in New York City (1972); Artpark in Lewiston, New York (1974); the Cooper-Hewitt Museum in New York City (1976); the Brooklyn Children's Museum (1977); the

St. Louis Art Museum (1977); the Madison, Wisconsin, Civic Center (1980); Spirit Square Art Center in Charlotte, North Carolina (1980); the Currier Gallery of Art in Manchester, New Hampshire (1982); the Toledo Museum of Art (begun 1982, to be completed in 1984); and the Los Angeles County Museum of Art.

Richard Meier

Born in Newark, New Jersey, in 1934, Richard Meier, F.A.I.A., received his architectural training at Cornell University (B. Arch., 1957). He established his own office in New York City in 1963. Meier was an adjunct professor of architecture at Cooper Union from 1964 to 1973, William Henry Bishop Visiting Professor at Yale University in 1975, 1977, and 1980–81, and a visiting professor at the Graduate School of Design at Harvard University in 1977 and 1980–81.

Richard Meier's firm has designed residences, housing, medical facilities, museums and other cultural facilities, commercial and industrial buildings, and town plans. Among these, his Smith House, Darien, Connecticut (1967), Westbeth Art-

ists' Housing, New York City (1970), Douglas House, Harbor Springs, Michigan (1973), and Bronx Developmental Center (1977) have won National Honor Awards from the American Institute of Architects. Meier has received other awards, including the Arnold W. Brunner Memorial Prize from the American Academy and Institute of Arts and Letters in 1972, the R.S. Reynolds Memorial Award in 1977, awards from *Architectural Record* and a 1979 *Progressive Architecture* award for the recently completed Atheneum in New Harmony, Indiana. In 1980 he won an international competition for Frankfurt's new Museum für Kunsthandwerk; the building is presently under construction.

Moore Grover Harper, P.C.

Moore Grover Harper, P.C., was founded in 1975, successor to Charles Moore Associates, formed in 1970. The firm is located in Essex, Connecticut, has seven principals and 16 employees, and engages in diverse projects, ranging from urban planning to the design of buildings, interiors, and furniture. Charles W.

Moore, F.A.I.A. (B. Arch., University of Michigan, 1947; M.F.A., Princeton University, 1956; Ph.D., Princeton University, 1957), the founding principal, also established the Berkeley, California, firm of Moore, Lyndon, Turnbull, Whittaker in 1962, and the Los Angeles firm of Moore Ruble Yudell in 1975. In 1962 Moore was named Chairman of the Department of Architecture at the University of California in Berkeley, and in 1965 he was named Chairman, and subsequently Dean, of the Department of Architecture of Yale University. He left that post to become Professor of Architecture in the School of Architecture and Urban Planning at the University of California at Los Angeles, in 1974. He also works with the U.C.L.A. practice arm, the Urban Innovations Group.

Recent works of Moore Grover Harper, P.C., include Jones Neurobiological Laboratory (1975) and Sammis Hall (1980), both in Cold Spring Harbor, New York; National Guard Armory in Norwich, Connecticut (1978); dormitories at Quinnipiac College in Hamden, Connecticut (1981); and the Riverfront Landing, Dayton, Ohio (1979). The Williams College Mu-

seum of Art in Williamstown, Massachusetts, is currently under construction.

Cesar Pelli

Cesar Pelli, F.A.I.A., was born in Tucumán, Argentina, and earned a Diploma Arquitecto from the Universidad Nacional (1949). In 1952, he came to the United States to attend the University of Illinois, where he received his degree two years later (M.S. Arch., 1954). For the next ten years he worked in the office of Eero Saarinen and Associates in Bloomfield Hills, Michigan, and New Haven, Connecticut. From 1964 to 1967, he was Director of Design at Daniel, Mann, Johnson and Mendenhall in Los Angeles. In 1968, Pelli became Partner for Design at Gruen Associates, Los Angeles. A year later, his design team won first prize in the competition for United Nations City in Vienna. In 1977 he was named Dean of the School of Architecture, Yale University, and he has since opened his office, Cesar Pelli & Associates, in New Haven.

Pelli's major works include the Pacific Design Center, Los Angeles (1971), the United States Embassy in Tokyo (1972), and the Rainbow Center Mall and Wintergarden in Niagara Falls, New York (1975), all done with Gruen Associates. Among current projects are the seven-million-square-foot commercial complex at Battery Park, New York, and the Museum of Fine Arts for the University of Texas at Austin.

Annotated Bibliography

Within each section of the bibliography, items are listed chronologically. For general works on the nature of museums and for references to specific museum buildings and projects, see the notes to the essay.

Books

Benjamin Ives Gilman. *Museum Ideals of Purpose and Method*. Cambridge, Mass.: Harvard University Press, 1923.

Gilman, for many years secretary to the Museum of Fine Arts in Boston, offers an erudite and ruminative treatise on the nature of art museums that can still be read with pleasure and profit. His reflective study includes three essays directly concerned with architecture, in which he analyzes existing museums and suggests more practical solutions: "A Museum without Skylights," pp. 139–61; "Glare in Museum Galleries," pp. 162–237; and "Basilica or Temple," pp. 435–42.

Lawrence Vail Coleman. *Museum Buildings*. Washington, D.C.: American Association of Museums, 1950.

Coleman covers American museums of all genres and provides the most complete statistical and pictorial survey of museum architecture in the United States published thus far. The indispensable Appendix lists chronologically every museum built between 1806 and 1949 and includes names of architects and costs of construction. There are useful tables comparing space distribution and cubic-foot costs in selected buildings, and a wealth of practical information on such relevant topics as planning and lighting. On the basis of his extensive research, Coleman concluded that "an ideal scheme has never been even envisaged, to say nothing of being carried out. Every plan involves compromises between more or less incompatible objectives and each project appears with its own unique set of only partly escapable frustrations" (p. iii).

Roberto Aloi. *Musei: Architettura, Tecnica*. Milan: Ulrico Hoepli, 1962.

Text in Italian and English. Generously illustrated compendium with a great deal of factual information on all types of recent museums. Three American art museums are represented: the Cullinan Hall addition to the Museum of Fine Arts in Houston by Ludwig Mies van der Rohe; the Munson-Williams-Proctor Institute in Utica by Philip Johnson; and the Guggenheim Museum in New York City by Frank Lloyd Wright.

Michael Brawne. *The New Museum: Architecture and Display*. New York: Frederick A. Praeger, 1965.

After a brief historical introduction, the text and illustrations comprehensively

explore museum design throughout the world from 1950 to the date of publication. There is a section on techniques of exhibition. The American art museums discussed are the Yale University Art Gallery by Louis I. Kahn; the Cullinan Hall addition to the Museum of Fine Arts in Houston by Ludwig Mies van der Rohe; Philip Johnson's Munson-Williams-Proctor Institute in Utica, New York, and his Sheldon Memorial Art Gallery in Lincoln, Nebraska; Wright's Guggenheim Museum; the addition to the Albright-Knox Art Gallery in Buffalo by Skidmore, Owings and Merrill; the Rose Art Museum at Brandeis University by Harrison and Abramowitz; and two projects that were subsequently executed; the Oakland Museum by Eero Saarinen and Associates, and the Everson Museum of Art at Syracuse Univerity by I. M. Pei and Associates.

Nikolaus Pevsner. *A History of Building Types*. Princeton, N.J.: Princeton University Press, 1976.

Chapter 8 is devoted to museums, and is useful for the discussion of the types of buildings which housed private collections from the Renaissance through the eighteenth century. There is good pictorial coverage, primarily of European examples, with the focus on museums of art. Excellent bibliography of publications (chiefly European) on the history of museum design.

Exhibition Catalogues

Henry-Russell Hitchcock. *Early Museum Architecture*. Hartford, Conn.: Wadsworth Atheneum, 1934.

This slim, scarce, but valuable pamphlet records a seminal exhibition organized to celebrate the opening of the Atheneum's Avery Memorial Wing. Basically a list of places, dates, and names of architects, with brief descriptions of each new building, remodeling, or addition, Professor Hitchcock's entries constitute a concise and convenient genealogy of early museum architecture. He cites the following: Museo Pio-Clementino in the Vatican, c. 1770–86; Musée du Louvre, 1784, Hubert Robert's project, 1806–10, Percier and Fontaine's execution; Musée des Monuments Français, remodeling of the ex-convent of the Petits-Augustins in Paris, 1796–1814; Dulwich College Picture Gallery, 1811–14; Glyptothek, Munich, 1816–30; Braccio Nuovo, new Vatican gallery, 1817–22; Altes Museum, Berlin, 1824–28; City Art Gallery, Manchester, 1824–34; British Museum, London, 1825–47; Alte

Pinakothek, Munich, 1826–33; National Gallery, London, 1828–37; Musée de l'École des Beaux-Arts, Paris, 1833–38; Thorvaldsen Museum, Copenhagen, 1839–48; Neue Pinakothek, Munich, 1846–53; Trumbull Gallery, New Haven, 1831–32; and Wadsworth Atheneum, Hartford, 1842–44.

Ludwig Glaeser. *Architecture of Museums.* New York: The Museum of Modern Art, 1968.

This is also a pamphlet but one with modest illustrations. It documents an intelligent and important exhibition concentrating on European and American museum design of the 1950s and 1960s. Glaeser's brief commentary is well worth reading; his thesis is that while "the educational role which the age of enlightenment intended for the museum has not only been revived but increased to an unforeseeable extent . . . the museum can never deny its original function of housing art."

A. Biermann and J.P. Kleihues, *Museumbauten: Entwürfe und Projekte seit 1945.* Dortmund, West Germany: Museum am Ostwall, 1979. (The catalogue appeared as vol. 15 of the *Dortmunder Architekturheft,* a book-length periodical that is published at irregular intervals.)

Unrealized projects as well as executed works are represented in this substantial (but unpaginated) volume, organized alphabetically by architect. Many conceptual sketches are included among its profuse illustrations. Although museums are seen as falling into one of three categories—Temple of the Muses, Place of Learning, and Annual Exposition [*Musentempel, Lernorte, Jahrmärkte*]—the authors emphasize formal diversity and note that in the twentieth century, "museums are one of the few commissions for which hitherto, fortunately, no guiding principles, special prescriptions or standardized concepts have been developed." The representation is preponderantly German but from the United States there are projects by John Hejduk (1967) and Mies van der Rohe (1942). The executed buildings are Louis I. Kahn's Yale University Art Gallery, Kimbell Art Museum, and Yale Center for British Art and I. M. Pei's East Wing addition to the National Gallery in Washington, D.C. The authors conclude that "for the architect, the planning of a museum presents itself as one of the last free areas for the design of projects which are 'artistically' ambitious."

Articles and Essays in Books and Periodicals

Cecil Brewer. "American Museum Buildings." *Journal of the Royal Institute of British Architects*, 3rd series, 20 (April 1913), pp. 365–403.

This English architect had a grant from the R.I.B.A. to study American museums and compile what must be the first such survey. He visited fifty institutions and selected for publication (and illustration) the Museum of Fine Arts in Boston by Guy Lowell; the Art Institute of Chicago by Shepley, Rutan and Coolidge; the Corcoran Gallery in Washington, D.C., by Ernest Flagg; and two museums by Green and Wicks: the Toledo Art Museum and the Albright-Knox Art Gallery in Buffalo (considered by Brewer "architecturally the most perfect art museum visited," p. 383). In Brewer's opinion, "There exists on both sides of the Atlantic a good deal of not unnatural dissatisfaction among museum directors at the existing buildings, and this dissatisfaction shows itself largely in indiscriminate abuse of architects, whom they are apt to consider merely as hindrances to museum progress" (pp. 365–66).

Richard J. Bach. "The Modern Museum: Plan and Functions." *The Architectural Record*, 62 (December 1927), pp. 457–69.

Averring that "museums and their work are unknown territory to the architect" (p. 457) and that "existing museum buildings are very expensive though elegant examples of what to avoid" (p. 465), Bach recommends that more attention be paid in design to educational functions. He disapproves of the traditional concept of the "museum as civic monument" and prophesies that "the newer museum creed will see less merit in a building set apart, find more promise in a building that hobnobs with others in a crowded city. This will mean museums in taller buildings" (p. 467). Illustrated without comment are the following, mostly traditional, museum buildings: Memorial Art Gallery in Rochester, New York, by McKim, Mead and White; Montclair Art Museum in New Jersey by Goodwillie and Moran; the San Diego, California, Art Museum by William Templeton Johnson; Rhode Island School of Design in Providence by William T. Aldrich.

Alfred Morton Githens. "The Trend of the Museum." In *American Public Buildings of Today*, edited by R.W. Sexton. New York: Architectural Book Publishing Company, 1931.

Githens, an architect with the firm of Tilton and Githens, defines the museum as "a Place to See Things. Therefore, more important than plan, appearance, grouping,

expression of a gracious ideal or anything else is the more practical, prosaic lighting of the galleries. Manifestly, plan and exterior are radically affected by the method of lighting adopted and it is this that must be determined first of all" (p. 130). The art museums that Githens illustrates are: the Detroit Institute of Arts by Paul Cret and Zantzinger, Borie and Medary; the Pennsylvania (now Philadelphia) Museum of Art by Horace Trumbauer with Borie and Zantzinger; the Rodin Museum, also in Philadelphia, by Paul Cret and Jacques Greber; the Museum of Fine Arts in Houston by William Ward Watkins; plus two by his firm: the Currier Gallery in Manchester, New Hampshire, and the Museum of Fine Arts (formerly Gray Museum) in Springfield, Massachusetts.

William Valentiner. "The Museum of Tomorrow." In *New Architecture and City Planning*, edited by Paul Zucker. New York: Philosophical Library, 1944.

A succinct statement reflecting thinking at the end of World War II on museums as architecture and institutions.

Philip Johnson. "American Museum Architecture." *The Indian Architect*, 5 (June 1963), pp. 32–34, 37–38.

Short but cogent consideration, by an architect who has designed a number of significant museums, contrasting two extremes in museum architecture—the multi-story loft, represented by the Museum of Modern Art, and the great room, seen at the Guggenheim.

Jay Cantor. "Temples of the Arts: Museum Architecture in Nineteenth-Century America." *The Metropolitan Museum of Art Bulletin*, 28 (April 1970), pp. 331–54.

Succinct but comprehensive building-by-building survey of galleries and museums in the first century of independence in America. Excellent text and good pictorial coverage.

Paul Goldberger. "What Should a Museum Building Be?" *Art News*, 74 (October 1975), pp. 33–38.

A critic discusses museum architecture of the first half of the 1970s, concluding that the Walker Art Center in Minneapolis by Edward L. Barnes is "the one setting for the display of contemporary art that has won virtually unanimous praise from critics and museum officials alike."

Issues of Periodicals Devoted to Museum Architecture

The Architectural Forum, 47 (December 1927).

A portfolio of museums: The Museum of Fine Arts, Boston; the Museum of Fine Arts, Houston; the Detroit Institute of Arts; the Isaac Delgado Art Museum, New Orleans, by Lebenbaum and Marx; the Toledo Museum of Art by Edward B. Green and Sons; the Cleveland Museum of Art by Hubbell and Benes; the Newark Museum by Jarvis Hunt; the Horace C. Henry Art Gallery in Seattle by Bebb and Gould; the Walker Art Gallery in Minneapolis by Long and Thorshov; the Rhode Island School of Design in Providence by William T. Aldrich; the Fogg Art Museum at Harvard by Coolidge, Shepley, Bulfinch and Abbott; the Heckscher Park Art Museum in Huntington, New York, by Maynicke and Franke; and the Mulvane Art Museum in Topeka, Kansas, by Thomas W. Williamson Company. McKim, Mead and White is represented by the Walker Art Gallery in Brunswick, Maine; the Butler Art Institute in Youngstown, Ohio; the Minneapolis Institute of Arts; the Brooklyn Institute of Arts and Sciences; and two additions to the Metropolitan Museum of Art in New York City. Charles A. Platt is represented by the Freer Gallery in Washington, D.C., and by two projects: one for the National Gallery of Art in Washington and the other for a museum in Wilkes-Barre, Pennsylvania.

Lorimer Rich, "Planning Art Museums," pp. 553–60.

Charles G. Loring, "A Trend in Museum Design," p. 579.

Henry W. Kent, "Museums of Art," pp. 581–84.

Meyric R. Rogers, "Modern Museum Design: As Illustrated by the New Fogg Museum, Harvard University," pp. 601–8.

The Architectural Record, 66 (December 1929).

Fiske Kimball, "The Modern Museum of Art," pp. 559–80; and "Planning the Art Museum," pp. 581–90.

Kimball was the director of the Pennsylvania Museum of Art and pioneered the installation of period rooms in American museums, so his comments on this point are particularly interesting. The first article is a history of museums and the second a discussion of technical issues. The illustrations are chiefly of the Pennsylvania (now Philadelphia) Museum and the Detroit Institute of Arts.

Erling H. Pedersen, "Outline Reminder for Museum Specifications," pp. 591–94.

Clarence S. Stein. "Renderings: Proposed Museum for Pasadena Art Institute and Museum of Wichita Art Institute," p. 595.

The Architectural Forum, 56 (June 1932).

"Eight Museums of the Fine Arts": The Joslyn Memorial Museum in Omaha, Nebraska, by John and Alan McDonald; the Louis Terah Haggin Memorial Galleries in Stockton, California, by William J. Wright; the Columbus Gallery of Fine Arts in Ohio by Richards, McCarty and Bulford; the Baltimore Museum of Art; the Dayton Art Institute in Ohio by Edward B. Green and Sons and Albert Hart Hopkins; the Rodin Museum, Philadelphia; the Ringling Museum of Art in Sarasota, Florida, by J.H. Phillips; and the Mystic Art Gallery in Connecticut by Jackson, Robertson and Adams.

Henry W. Kent, "The Why and Wherefore of Museum Planning," pp. 529–32.

Lee Simonson, "Museum Showmanship," pp. 533–40.

"Museum Remodelling and Restoration: Whitney Museum of American Art and the Municipal Museum of the City of Baltimore," pp. 605–8.

Clarence S. Stein, "Making Museums Function," pp. 609–16; and "Two Museums [Pasadena and Princeton University]," p. 617.

Isadore Rosenfield, "Light in Museum Planning," pp. 619–26.

Samuel R. Lewis, "Museum and Library Practice in Heating and Ventilating," pp. 635–39.

Progressive Architecture, 50 (December, 1969). Issue devoted to the theme "Today's Museum—Theatre or Mausoleum?"

C. Ray Smith, "The Great Museum Debate," pp. 76–85. Noting that a "great museum debate now rages: monuments vs. nonbuildings, permanent collections vs. traveling exhibitions, glass cases vs. environmental barrages" (p. 76), Smith examines the basic process of planning a museum and the pitfalls common to designing them. The article is supplied with statistics which fill the gap between the

publication of Lawrence Vail Coleman's *Museum Buildings* (1950) and 1969. Illustrated and discussed are the Pasadena, California, Art Museum by Ladd and Kelsey; the University Art Museum in Berkeley, California, by Mario Ciampi and Associates; the Kimbell Art Museum in Fort Worth by Louis I. Kahn; the Brooklyn Children's Museum by Hardy Holzman Pfeiffer Associates; the Florida State Museum in Gainesville by William Morgan; and the University of Pennsylvania Museum Academic Wing in Philadelphia by Mitchell/Giurgola Associates.

There are also articles on the Hudson River Museum by the SMA Partnership (pp. 86–91), and the Oakland Museum by Kevin Roche and John Dinkeloo (pp. 92–95).

Progressive Architecture, 56 (March 1975).

Every section of this issue—Editorial, News Reports, Interior Architecture, Technics—is devoted to museums. Editor John Morris Dixon comments: "There are many roles for museums in our society and all of them have some effect on the architecture that contains them and symbolizes them" (p. 41). Among these roles are "public treasure house . . . conspicuous display of private acquisitions . . . agent of social uplift . . . community bulletin board . . . monumental coffee table" (p. 41). There are also articles on the Hirshhorn Museum and Sculpture Garden in Washington, D.C., by Skidmore, Owings and Merrill (pp. 42–47); the Minneapolis Institute of Arts expansion by Kenzo Tange (pp. 48–51); and the Contemporary Arts Museum in Houston by Gunnar Birkerts (pp. 52–57).

Progressive Architecture, 59 (May 1978).

After the Introduction, "Museums With Walls" (p. 61) by Suzanne Stephens, the following American art museums are discussed: the Brooklyn Children's Museum by Hardy Holzman Pfeiffer Associates (pp. 62–67); the Yale Center for British Art by Louis I. Kahn (pp. 76–81); Richard Meier's New York School exhibition gallery in the New York State Museum at the Albany Mall (pp. 72–75); and the Southern Alleghenies Museum of Art in Loretto, Pennsylvania, a conversion by Roger Ferri and L. Robert Kimball.

Perspecta: *The Yale Architectural Journal*, 16 (1980).

A portfolio of 30 museum plans from the fifteenth century to the present, drawn at a scale of 1:50 or 1:100, collected by Kirk Train.

James Stirling, "The Monumental Tradition," pp. 33–49. Projects for the Kunstsammlung Nordrhein-Westfalen in Düsseldorf, the Wallraf-Richartz-Museum in Cologne, and the Staatsgalerie extension in Stuttgart.

David Spiker and Kirk Train, "The Yale Center for British Art," pp. 50–61.

Michael Dennis, "The Uffizi: Museum as Urban Design," pp. 62–71.

"The Museum of Modern Art Project: An Interview with Cesar Pelli," pp. 97–107.

Photograph Credits:

In most cases, photographs of museum buildings have been provided by the institutions cited in the captions, and photographs of models, drawings, and plans for projects have been provided by the architectural firms. The following list applies to photographs for which an additional acknowledgment is due.

Lois Bowen: Fig. 36

Stuart Bratesman: pp. 122, 127–29

Tom Brown: Fig. 62

Louis Checkman: pp. 89–91

Robert Harris: Fig. 21

Wolfgang Hoyt, Esto Photographics, Inc.: pp. 78, 82, 83, 85

Nathaniel Lieberman: pp. 104, 105

Robert E. Mates: Fig. 48

The Museum of Modern Art, New York: Fig. 44

The New-York Historical Society: Fig. 14

I.M. Pei & Partners: Figs. 58–60

Kevin Roche John Dinkeloo and Associates: Figs. 55–57

Smithsonian Institution, Washington, D.C.: Fig. 17

Ezra Stoller, Esto Photographics, Inc.: Figs. 50, 51; pp. 112, 113

Joseph Szaszfai: Fig. 63

Jerry L. Thompson: Fig. 54

The Trustees of Sir John Soane's Museum: Fig. 11

This publication was organized at the Whitney Museum of American Art by Doris Palca, Head, Publications and Sales; Sheila Schwartz, Editor; James Leggio, Associate Editor; and Sarah Trotta, Secretary.

Designer: Heidi Humphrey
Typesetter: Trufont Typographers, Inc.
Printer: William J. Mack Company